IMAGES
of America

TACOMA'S
HAUNTED HISTORY

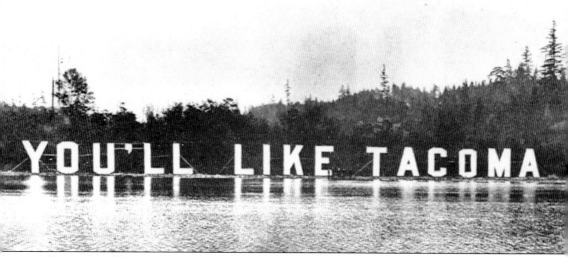

YOU'LL LIKE TACOMA. Now a midsize city, Tacoma was brought to life by the Northern Pacific Railway. The area around the railway terminus was quickly populated with commercial and residential areas. While the city has spread and the population has grown, the downtown area remains a central hub for all the activities in Tacoma. Many historic buildings remain in the area, including the old city hall, Elks Lodge, Union Station, Hotel Winthrop, Bostwick Building, Pythian Temple, and Pantages and Rialto Theaters. (Washington State Digital Archives.)

ON THE COVER: With the camera pointed south from a location on the steep slopes, this stunning 1910 photograph from the Richards Studio Collection displays the railroad yard, the Tacoma tideflats, and Mount Rainier in the background. The banner hanging over Pacific Avenue reads "You'll Like Tacoma." The old Tacoma City Hall and Northern Pacific headquarters appear in the upper right. (Tacoma Public Library.)

IMAGES
of America

TACOMA'S
HAUNTED HISTORY

Ross Allison and Teresa Nordheim

ARCADIA
PUBLISHING

Published by Arcadia Publishing
Charleston, South Carolina

Printed in the United States of America

Library of Congress Control Number: 2013944410

For all general information, please contact Arcadia Publishing:
Telephone 843-853-2070
Fax 843-853-0044
E-mail sales@arcadiapublishing.com
For customer service and orders:
Toll-Free 1-888-313-2665

Visit us on the Internet at www.arcadiapublishing.com

My "dead-ication" goes to my great-grandma:
Barbara L. Allison
08/18/17–03/09/13
You will be missed.
And to Teresa—without you, this book would not be possible.

—Ross

To Cindi, Katerina, and Kaeloni—my past, present, and future

—Teresa

CONTENTS

ACKNOWLEDGMENTS

Several wonderful individuals helped bring *Tacoma's Haunted History* to life, and we would like to thank them for their contributions. To the entire staff of the Tacoma Public Library's Northwest Room, thank you for your never-ending supply of answers and information. Your willingness to listen and assist us with this quest was invaluable. Steve Dunkelberger, thanks for helping spread the word about our book and for all of the information you offered. Karla Stover, thank you for sharing your wealth of historical knowledge of Tacoma. William Pierce Bonney and Herbert Hunt, you won't be forgotten; thank you for your work on historic preservation and volumes of information. Tacoma Historical Society and Washington State Historical Society, thank you for your encouragement. Mary Johnson, thank you for allowing us to share in your experience. Charlie and Andrew Hansen of Terrified in Tacoma Ghost Tours, thank you for all of your help in this project. The staff of Spooked in Seattle Ghost Tours, we couldn't have done this without you. Our family and friends, thank you for your patience and forgiving natures during our long work hours; this book wouldn't be possible without your love, support, and reassurance. AGHOST team, thank you for your investigational work and your unconditional faith in our ability to present our research. Thank you to all the photographers who made this book possible. Without all of you, the past would be nothing more than a ghostly void. To our readers, a special thank you. Finally, we would like to thank all the Tacoma ghosts. Without you, none of this would be possible.

Unless otherwise noted, all photographs are courtesy of the following organizations and individuals: US National Archives (USNA), Washington State Digital Archives (WSDA), *Tacoma Daily Ledger* (TDL), *Tacoma News Tribune* (TNT), Tacoma Public Library (TPL), Library of Congress (LOC), William Pierce Bonney (WPB), June Nixon (JN), Joe Mabel (JM), Ben Cody (BC), Steve Pavlov (SP), Florida State Archives (FSA), Sverre-Andre Nordheim (SN), and authors' collection (AC).

INTRODUCTION

Tacoma has a rich history that dates back many years. Native Americans from the Puyallup and Nisqually tribes formed settlements near the large bay at the base of a majestic mountain. With over 18,000 acres of bayfront property, they could harvest clams, fish, and maintain an ample lifestyle. The large trees and gentle waters protected the community.

England sent Capt. George Vancouver to explore the coastline of the United States and the Pacific Ocean. In command of the British naval ship *Discovery*, Vancouver and his crew entered the Strait of Juan de Fuca in April 1792. He named and mapped every spot of land and water they discovered, even those previously named by the locals. The crew also researched the flora and fauna of the area. In May, Vancouver sent Lt. Peter Puget and a small crew to explore remote waters. Before returning, Puget named the large sound of water after himself. Rear Adm. Peter Rainier, a Navy friend of Vancouver, inspired the name of the majestic Mount Rainier. Before completion of their expedition, they had named, renamed, and claimed lands formally claimed by Spain. The English crew left the area and returned home.

The Hudson Bay Company expanded to the West Coast and formed the Columbia District. This district would oversee the daily operations of the many fur trading posts. The company built Fort Vancouver in 1824 and Fort Langley in 1827 but needed another fort at the center point between these two posts. That midpoint, with the friendliest natives, was at the Nisqually River Delta, in the present town of DuPont. The first European trading post in the Puget Sound was constructed and named Fort Nisqually in 1833. By 1843, the fort had outgrown its original site and moved one mile north. Another relocation and restoration of Fort Nisqually took place in the 1930s. Workers transported pieces of the original structure to Point Defiance, where it became a living-history museum.

Lt. Charles Wilkes led the first US Navy expedition to explore the Puget Sound area in 1838. He named, or renamed, and surveyed many of the locations and landmarks. As the originating point for its maps, the expedition named the large bay Commencement Bay.

In 1852, a Swedish man by the name of Nicholas DeLin arrived at Commencement Bay. DeLin found financial backers for a small water-powered sawmill on the shores of Commencement Bay and promptly began construction. Settlers would bring in raw timber, and DeLin paid them in wood rather than cash. The mill provided a small port for the city. Soon after, logging, sawmilling, farming, fish packing, fishing, and barrel making brought more citizens to the area. However, the comforts of home would not last for very long.

From 1855 to 1856, the Puget Sound was a war zone. Conflicts between the white settlers and the natives reached a magnitude of frightening capacity. The war began over land rights under the Treaty of Medicine Creek in 1854. The site of the treaty was near the delta of the Nisqually River and granted 2.24 million acres of land to the United States in exchange for the establishment of three reservations for the natives to live on, cash payments over 20 years, and recognition of hunting and fishing rights for the tribes. Chief Leschi and his tribe chose to fight rather than

hand over their land. The death of US military officer Abram Benton Moses would go down in the history books for the controversial trial that followed. Upon hearing the news about the death of the military officer, Gov. Isaac Stevens sent men to retrieve Chief Leschi. Accusers brought murder charges against the tribal leader. The first trial resulted in a hung jury as the various parties debated the legitimacy of a murder charge during a time of war. At the next trial, in 1857, Leschi received a guilty verdict and was sentenced to death by hanging. The execution of Chief Leschi took place on February 19, 1858. In December 2004, a historical court reexamined the case and ruled Leschi was not accountable for a death that occurred during a time of war, exonerating him of wrongdoing. The ruling held no legal status, but it did provide a small amount of comfort to the Nisqually tribe, which was proud of its legendary leader. As for DeLin and the rest of the settlers in Commencement Bay, they fled for safer grounds and never returned.

Job Carr arrived at the future site of Tacoma on Christmas Day, 1864, and was the first white settler to arrive after the abandonment of the area in 1855. Carr had visited Olympia, Steilacoom, and even Seattle before discovering the spot along Commencement Bay. He knew the Northern Pacific Railway was seeking a location for its terminus, and when he spotted the natives' beached canoes and protected land inside the bay, he shouted, "Eureka! Eureka!" Carr gambled on the land's value when he staked a claim to over 168 acres of land. He built a cabin and settled. His sons arrived in 1866. They also staked a claim to many acres of land. Eventually, his two daughters and ex-wife would come west as well. Carr was a tireless promoter of Commencement Bay for the railroad terminus, and settlers came to join him in hopes of potential wealth. While he waited, he took on several lead roles in the community. He also took many of the first photographs of the area. Unfortunately for Carr, in 1873, the railroad selected land two miles south of his claim.

The land belonged to Gen. Morton McCarver, who had been heavily marketing the area as "where sails meet rails." At the time, locals called the area Commencement City or Puyallup, but after a suggestion by Philip Ritz of the Northern Pacific Railway, McCarver changed the name to New Tacoma, the area's Native American name. McCarver came to the Puget Sound in 1868 after speaking to Nicolas DeLin, and procuring a map for the area, he decided it would be the perfect location for the railroad terminus. In fact, he purchased land from Job Carr.

The Northern Pacific Railway built a headquarters in what is now downtown Tacoma, and South Tacoma housed the commercial and residential area for the workers. In 1873, the railroad hit its first stumbling block. It had drastically underestimated the cost of building the railroad into a wilderness area. The Panic of 1873 hit everyone hard; many companies and private citizens struggled to make ends meet financially. In 1875, the Northern Pacific Railway slipped into its first bankruptcy. Construction from that point forward would move at a snail's pace, and just when the railroad felt it was safe, the Panic of 1893 hit. This would be the first serious economic depression in the United States and marked the collapse of the railroad.

By 1883, the population of New Tacoma had reached over 4,000 despite the economic crashes. Carr's town (Old Tacoma or Tacoma City) had a population of approximately 400. Eventually, the two towns would combine, but it wouldn't be enough to save the fate of this agreeable bay town.

Throughout the years, this once-great city has drifted into the dark shadows of the booming city of Seattle, with much of its history and legends swept deep under its cold, damp streets. Here, there are secrets to be told if you are willing to press your ear hard enough to the walls that mysteriously speak. Listen, and you will find stories bringing light to the city's troublesome and painful past that embraces the ghosts wandering within the darkness.

They say ghosts are nothing more than just stories of our past projecting themselves on the partitions like an 1800s silent film of flickering light and dancing shadows, like trapped memories of the lives that lived within these hallowed walls echoing throughout the night. They came here to make something of themselves, perhaps consumed by jealousy or greed, looking for true love, or just at the wrong place at the wrong time, and in their afterlife, they want their stories to be told. But just like any other metropolitan landmark, they have been consumed and forgotten.

Science has no definite answer as to what lurks among these haunted grounds. Popular belief tells us these phantasms are the souls of those who have passed. Others say it is nothing more than just tricks of the mind. Whatever your belief is in the world of unexplained events, there is a mystery afoot that drives the curious mind to this realm. A wise man once said, "There are more things in heaven and earth than are dreamt of in your philosophy."

Many individuals believe in a variety of extraordinary things. The belief in ghostly inhabitants, however, is nothing new. The earliest-kept records of our past reveal ample proof of many strange encounters with the spirit world, and why is that? Spirits dwell for a number of reasons. They are attached to a person, place, or thing to which they had a strong personal connection during the course of their lives. Perhaps they wish to watch over the living, experienced a sudden or premature death, have unfinished business, or are unaware that they have indeed passed. These key elements trigger something within the universe's energy that surrounds us, creating an interactive environment with those from our past.

Spiritualism, which came about in the 1840s and grew ever so popular by the 1920s, had a strong presence here in Tacoma, and a basic form of this practice can be traced back thousands of years to its early inhabitants, the Nisqually and Puyallup tribes. A part of the Coast Salish Native American tribes that populated the northwest coast, they were very spiritual people who held many beliefs in a spiritual world and sacred lands. Here, their ancestral roots and remnants are buried deep within the city's soil. The city's name, Tacoma, comes from the native word *Tahoma* (meaning "the nourishing breast" or "near to heaven"), referring to the great mountain nearby known as Mount Tahoma, later renamed Mount Rainier, or to Commencement Bay (also known as the "Harbor of Phantoms"). The Native Americans who roamed these lands were at one with Mother Earth and the spirits that resided among them.

When the Nisqually people had to deal with their dead, they practiced a few different rituals. Those along the water banks often placed their dead in trees, with gifts and personal belongings beside them. According to the Puyallup Native American tribe, the higher in the tree, the more important a figure the person was in life. Once the body decayed and fell to the ground, the remains were buried nearby. Those farther inland placed their dead directly in the ground, in a sitting position, with their face pointing to the west.

Today's claim of modern homes and businesses being built on Native American burial grounds could very well be possible. As the white settlers populated more ground, they were known to remove the bodies and bury them elsewhere. So not only did Tacoma's citizens struggle to make a life for themselves in a growing city, but the Nisqually and Puyallup tribes also made sacrifices to share the land with the overpowering white man. These events and other past tragic encounters have scarred the property that many call home and others call Tacoma.

One

SPIRITUALITY

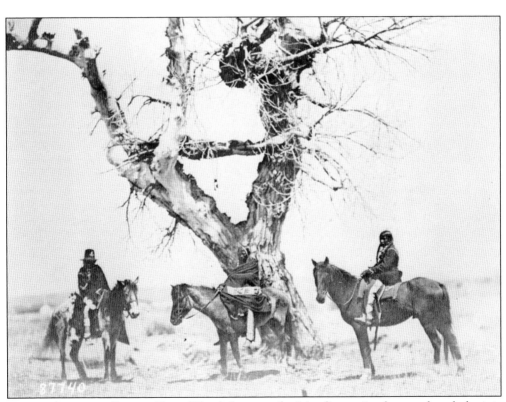

NATIVE AMERICAN BURIAL TREE. The definition of spirituality varies, but on the whole, it is the search for something sacred. Native American tribes have practiced spiritual rituals for many years. The late 1800s to early 1900s brought a rise in spirituality to Tacoma. Often called seers, those with abilities would predict the future for a few coins. Locals gathered for séances to contact the dead, and the belief in such practices increased in popularity among the European settlers. (USNA.)

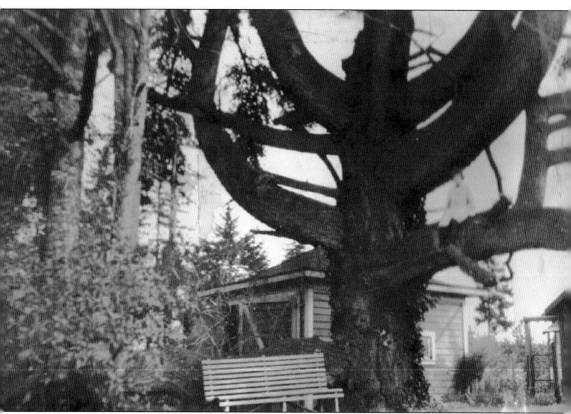

MANITOU TREE. Known as the Manitou Tree, this old bent fir tree that once stood tall at 6423 South Verde Street is now nothing more than a framed rotting stump in someone's front yard. Yet this location had, or even still has, a very strong spiritual calling. Before the white men populated the area, the Native Americans believed that this was sacred ground and very well could have used this tree for burial of their high-profile leaders. Later, it was used as a shelter for a local church known today as the Manitou Church, which was founded in 1912. Many sermons and Sunday school classes were held beneath its branches. Throughout the years, however, this tree took on time and was even struck by lightning to the point where many of the locals felt it was in danger of falling, so it was cut down. Today, many folks who live near the remains of the old tree have reported hearing old church songs sung in the heavenly voices of children. Others say this location holds a very peaceful feeling and a sense of calm. (TNT.)

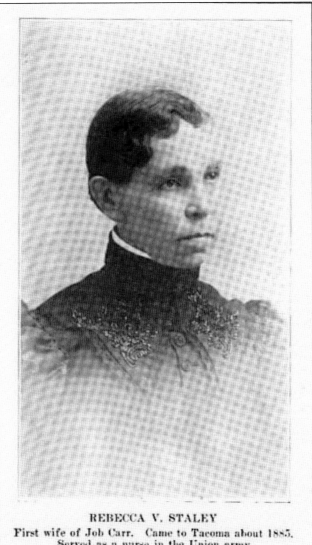

REBECCA V. STALEY
First wife of Job Carr. Came to Tacoma about 1885.
Served as a nurse in the Union army

REBECCA CARR. Rebecca Carr, also known as "Grandma Staley," would become Tacoma's most well-known person to possess the gifts of clairvoyance, more commonly known in the early 1900s as a seer. Her talent drew men and women from all over the world. Sailors who happened to be in port would ask her about their upcoming travels or about their families back home. Future brides would want to know if the man they were about to marry was the right one. Countless businessmen did not make a move without consulting her. And when it came to sickness, several believed she had saved lives. Although she was often thought of as a fortune-teller, she hated that designation. She preferred calling it the ability to "see," not fortune-telling. She made her living by "seeing" for folks and charging a dollar for an interview. However, most of the children called her "the witch" because she always wore a black sunbonnet and a black dress. Divorced from Job Carr and later remarried for her nickname, she and Job remained good friends, and when her later husband had passed, she moved to Old Tacoma in 1867 to be with their children. She passed away at the age of 77 on December 12, 1908, and is buried beside Job Carr in Tacoma Cemetery. (Herbert Hunt.)

ADVERTISING FOR TACOMA THEOSOPHICAL SOCIETY. Following the longtime practice of spiritualism in the 1840s, churches and societies colonized the Tacoma region, engaging in many ways to make contact with the other side. These groups would gather at various locations throughout Tacoma, groups like the Tacoma Psychic Society, Society of Spiritual Truth, Tacoma Theosophical Society, Universal Spiritual Society, Christian Spiritualist Church of Unity, Tacoma Spiritualist Church, and of course, Progressive Psychic Society, which dates back to as early as 1909. These organizations offered classes, lectures, events, and the ever-popular "circles," more commonly known today as a séance, in which they sat in a circle in order to communicate with the spirit world. The Progressive Psychic Society's reputation had moved it from general meeting locations to its own establishment at the old music hall that once stood at South Third Street in 1913. However, by 1921, the Tacoma Theosophical Society had taken over this space. Guest speakers included Minnie Perkins, Mrs. J.A. Bennett, Mr. Kringle, Mrs. L.F. Lundeen, Mrs. Lela Combs, Mrs. Hare, Reverend Dr. Coons of Seattle, Mrs. Stevens, Dr. T.W. Butler, and Mrs. Edward Nevers. (TDL.)

Ray Theater TWO NIGHTS— MON. & TUES., Jan. 28 & 29.

Adults 35c - - Children 25c

ASK MURDOCK
The Man Who Knows

Hindo Magic| Illusions
Startling - Weird - Mystery ·

SPIRITO SEANCE MURDOCK WILL
 TELL YOU ALL

DIRECT FROM TACOMA THEATER.

Tᴀᴄᴏᴍᴀ Oᴘᴇʀᴀ Hᴏᴜsᴇ, Aʟsᴏ Kɴᴏᴡɴ ᴀs Tᴀᴄᴏᴍᴀ Tʜᴇᴀᴛᴇʀ. Built in 1889 by the Tacoma Opera House Company and opened on January 13, 1890, this massive building once covered an entire city block. Harry Houdini performed his magic show in the theater. This venue was also a gathering spot for seers to perform in front of a crowd of people, casting their views of the future for a fee. Those studying the spiritual world gathered here to attempt to contact the dearly departed. They held séances and often invited the public to attend and watch the events unfold. In 1927, the opera house was remodeled into a motion picture theater, and the name changed to Broadway Theater. Over 20,000 people attended the grand reopening. In 1933, it was renamed the Music Box Theater. However, this theater would disappear about 30 years later in a blaze of flames. Around 100 people were attending the Alfred Hitchcock thriller *The Birds* when the fire broke out. Moviegoers exited the theater without panic after smelling smoke. The cause was a burned-out bearing in a ventilating fan, and the theater was destroyed. (TDL.)

JUDITH ZEBRA "J.Z." KNIGHT. On February 18, 1977, at 2:30 in the afternoon, Judith Zebra "J.Z." Knight, born Judith Darlene Hampton, was in the kitchen of her Lakewood home when she lost consciousness. She would later reveal that Ramtha, a Lemurian warrior who fought the Atlanteans over 35,000 years ago, came before her to state he was there to help her over a ditch. She was to become the first student, and eventually teacher, of his great work. Through spiritual channeling, Knight could receive messages from the entity and pass them on to others. About 10 years later, Knight would open Ramtha's School for Enlightenment in Yelm, Washington. Ramtha, who she channels for the students, often leads her teaching sessions. Her methods have sparked controversy and criticism, but the school currently has an enrollment of over 6,000 students. The home where she first channeled Ramtha still stands today, but she has relocated to a larger home near her school in Yelm. (J.Z. Knight.)

Two

CENTRAL TACOMA

EARLY CRIME IN CENTRAL TACOMA. As the name suggests, Central Tacoma is located right in the heart of the city. The original settlers in this area were quite diverse, coming from different countries, backgrounds, races, and religions. Many of the European immigrants brought their own languages, foods, cultures, and traditions. While not as old as other parts of Tacoma, Central Tacoma still offers a reflection of another time. (AC.)

Man Confesses Killing Two Tacoma Women

TACOMA, Oct. 30. — (AP) — A mother and her 17-year-old daughter were found slain early today in their South Side home, and Detective Lieut. Earl Cornelison said a 45-year-old transient had confessed the slayings.

Cornelison identified the victims as Mrs. Bertha Kludt, 53, a widow, and her daughter, Beverly June.

Both women had been struck on the back of the head with a heavy instrument.

Cornelison said two officers, A. P. Sabutis and Evan Davies, were called to the house when neighbors heard screams. As they approached, a man burst out the back door past Sabutis and toward Davies, who gave chase.

The man, who Cornelison said identified himself as Jake Bird, was cornered in nearby brush and subdued. Both officers were cut in the struggle by what they said was a large spike the man carried. Satbutis was cut in the back and Davies suffered badly cut hands.

Both Sabutis and the arrested man were hospitalized, the officer with a serious back wound from the spike and Bird with head and face cuts received in his fight with

—Morley Studio photo.

BEVERLY KLUDT
Victim of killer

INSIDE THE SHAW BUILDING. Constructed in 1928, the Shaw Building originally housed the Knights of Columbus, the largest Catholic fraternal organization in the world. On August 30, 1937, the body of the lodge's financial secretary, Eugene Gaudette, was found lying lifeless on the floor of the east side of the hall. A short length of cotton rope tightly encircled his neck, and a jagged gash about three inches long covered the back of his head. Police suggested all signs pointed to self-strangulation, but accounts from friends of Gaudette would indicate he was happy, stable, and in good standing with the lodge. The safe at the lodge was open, but the contents were intact. The coroner hesitated to sign the death certificate, even after an autopsy, as he felt strongly Gaudette's cause of death could have been murder. (Above, AC; below, TPL.)

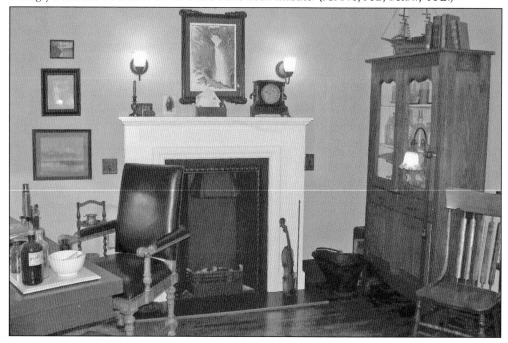

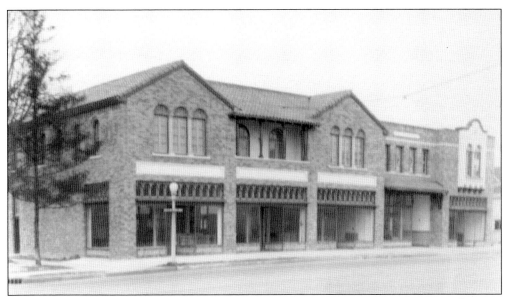

EUGENE GAUDETTE. Whether it was suicide or even possibly murder, it seems Eugene still lingers around the old lodge. The owners today have taken great pride in caring for this historic building that now operates as a costume shop. Here, its history still shines through and seems to have a story or two to tell. Throughout the years, the owners have restored many of the rooms, one of which was Eugene's old office, which now holds a beautiful Sherlock Holmes museum. It is here that many can feel the energies of the past pressing upon them. Could it be Gaudette himself? Or are the antiques still holding on to their treasured memories? On one occasion, the owner and a few customers witnessed a shadowy figure pass by from the main storefront to a nearby room, where an employee experienced the presence as well. If it was the dearly departed Eugene Gaudette, maybe he just wanted the mystery of his death to be revealed. As Sherlock once stated, "The game is afoot." (Both, AC.)

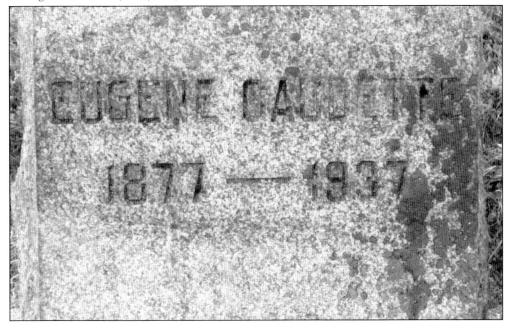

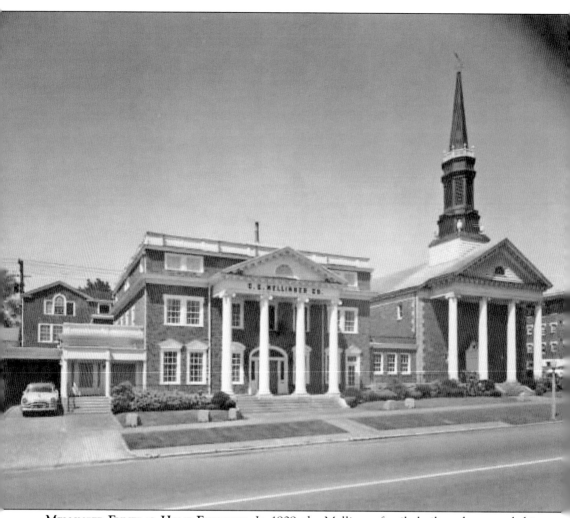

Mellinger Funeral Home Exterior. In 1909, the Mellinger family built and operated this Colonial-style mortuary. C.C. Mellinger was an Ohio native who began his undertaking career in 1897 with a small-scale company in Tacoma. His company quickly grew to become one of the largest in the city. A black-clad driver would chauffeur the sleek black Studebaker hearse from the mortuary to the cemetery. Another car transported the floral arrangements to the funeral. The Mellingers later joined their two mortuaries to form one large company, which is still in business today. From 1975 to 1985, the building served as a substation of the Pierce County Sheriff's Department. It now serves as a private nonprofit mental health services agency. (TPL.)

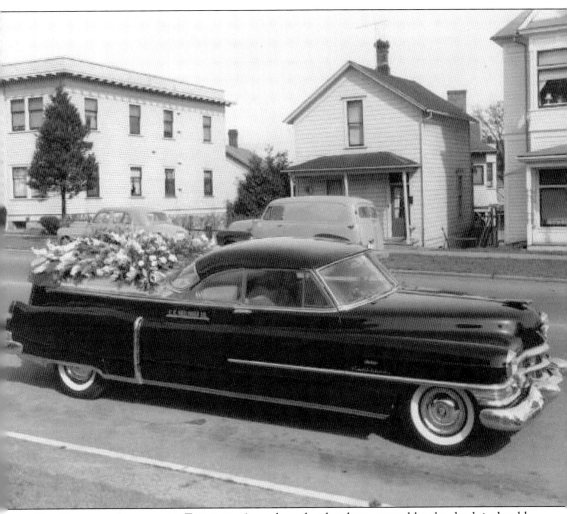

CAR CARRYING FLOWERS TO FUNERAL. As a place that has been graced by the dead, it should come as no surprise that an establishment with a history as a funeral home is haunted. Besides a cemetery, this is truly the next best thing. Most funeral homes deny the presence of any ghostly inhabitants due to their practice of making the living feel at ease after a great loss. That is the last thing those who have suffered a loss need to worry about at such a difficult time. So the tight-lipped service when it comes to whether these establishments are haunted is respectable. However, it has become commonly known that what was once a funeral home in the past and now servers as another business can be quite haunted. So it is no shocker that this site has had a few bumps in the night. (TPL.)

ENGINE HOUSE NO. 9. After the Great Seattle Fire of 1889, the Tacoma city council voted to put its volunteers on a salary. Tacoma was one of the first cities in the state to establish a paid fire department. Today, this location serves as a restaurant and living-history museum of firefighter paraphernalia. Built in 1907, the building served as a firehouse, providing protection to the city. For many years, it was the battalion headquarters. Engine House No. 9 was the last station to convert from horse-drawn to mechanical equipment. The area that presently serves as the bar holds the old horse stalls. Each stall is marked with the name of the horse that resided there. When the station ceased service in 1965, the building sat abandoned and fell into disrepair. After its rediscovery in 1972, renovation and restoration brought life back to the old firehouse. (Left, AC; below, WSDA.)

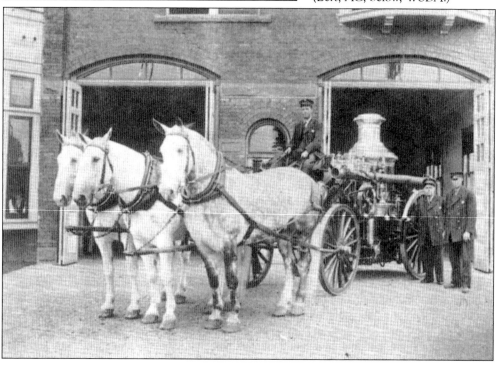

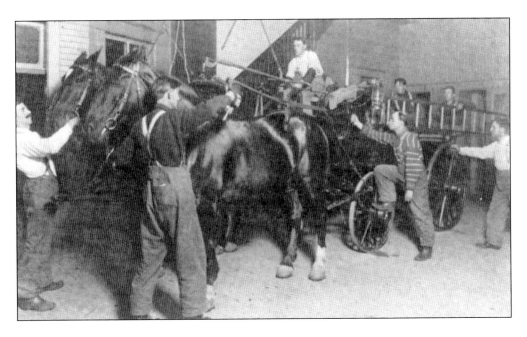

HAUNTED FIREHOUSE. Any firefighter can tell you theirs is a dangerous job, but in the early 1900s, it was far more treacherous. Firehouses across the nation have tales of firefighters who have fallen while in the line of duty then return to what some may consider their second home. The bond between these men and women is always strong, for they have to look out for each other, and maybe they continue to do just that in the afterlife. The staff here has seen some pretty interesting things, from an odd sound such as a horse neighing to things moving, but the most interesting is the sighting of a man in the windows of the upper floor when the building is closed for the night. (Above, AC; below, WSDA.)

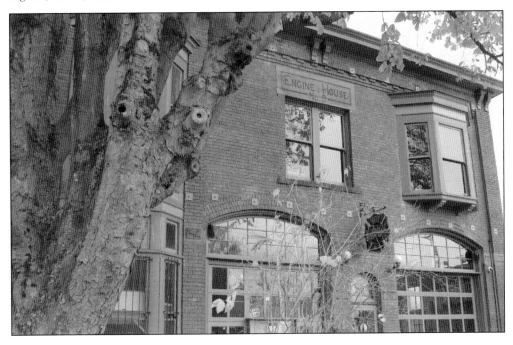

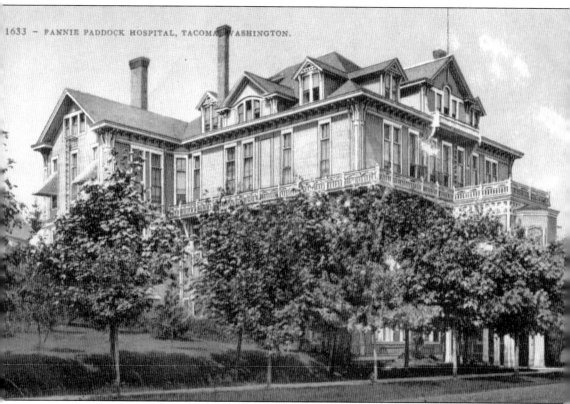

FANNIE PADDOCK MEMORIAL HOSPITAL. In 1880, Fannie Paddock was preparing to move from New York to Washington. Her husband, Bishop John Paddock, had been chosen to lead the Protestant Episcopal Church in Tacoma. Fannie asked her husband what was needed in Tacoma, and he told her the growing number of diseases and lack of health care was a problem. She immediately began raising funds to build a hospital. During their travels west, Fannie contracted typhoid, and she died shortly after reaching Tacoma. Exactly one year later, her husband opened and dedicated the Fannie Paddock Memorial Hospital. Improved health care reduced the number of deaths from diseases such as influenza, typhoid, smallpox, and tuberculosis. This first hospital in Tacoma started in a renovated dance hall and grew to become Tacoma General Hospital. The hospital morgue has had copious visitors over the years and continues to host the victims of disease, accidents, or natural causes. (WSDA.)

npjot. 10

RETURN OF A DEATH.

No. OF RECORD. No. OF BURIAL PERMIT.

Tacoma, Pierce County, Washington.

NO INCOMPLETE RETURN WILL BE ACCEPTED.

1. Name, in full *Chancey Whittery Woodruff*

2. Color: 3. Sex: 4. Conjugal Condition:
 White. Male. ~~Single.~~
 ~~Black (Negro or mixed).~~ ~~Female.~~ Married,
 ~~Indian.~~ Widowed.
 ~~Chinese.~~ ~~Divorced.~~
 ~~Japanese.~~

 NOTE—For questions 2, 3, and 4, strike out words not applicable.

5. DATE OF DEATH... { Year. *1900* / Month. *July* / Day. *5th* }
6. OF BIRTH { Year. / Month. / Day. }
7. AGE { Years. *46* / Months. / Days. }

8. OCCUPATION *Blacksmith*
 (Return occupation for all persons 10 years of age and over.)

9. PLACE OF BIRTH *Illinois*
10. BIRTHPLACE OF FATHER *Unknown* STATE OR COUNTRY
11. BIRTHPLACE OF MOTHER *Unknown*

12. DISEASE OR CAUSE OF DEATH DURATION
 CHIEF CAUSE *Street Car accident*
 CONTRIBUTING CAUSE
 Place where disease was contracted, if other than place of death, *D. Lin St. Bridge* *Tacoma Wash*

13. PLACE OF DEATH, No. *(D. Lin Street Bridge)* STREET, WARD.
 If death occurred in an institution, give the name of same, *Fanny Paddock Hospital*
 Length of time deceased was an inmate, *one day*, and previous residence, *Seattle — Wn*

14. LATE RESIDENCE
 Length of Residence (in city)

 UNDERTAKER. *C L Hoska*

 PLACE OF INTERMENT. *Tacoma Cemetery*

 SIGNATURE, *Conrad L Hoska*
 (Of Physician or Coroner.)

 DATE OF CERTIFICATE. *July 7* 1900

DEATH CERTIFICATE FROM FANNIE PADDOCK MEMORIAL HOSPITAL. Like any hospital, death continues to frequent this location. The sick and injured will die, and some will cling to as much of life as possible, leaving an empty shell of their lives hovering around these premises. Unfortunately, this building is no longer standing; it was torn down and replaced with a new structure. The newer building, however, has a few hauntings of note. There is what is believed to be a nurse still roaming the halls, her heels heard clacking up and down the linoleum floors. Nearby is an elevator that is known to run on its own as well. At the Mary Bridge Children's Hospital, staff have reported seeing and hearing a ghostly young child pulling a red wagon through the halls. (WSDA.)

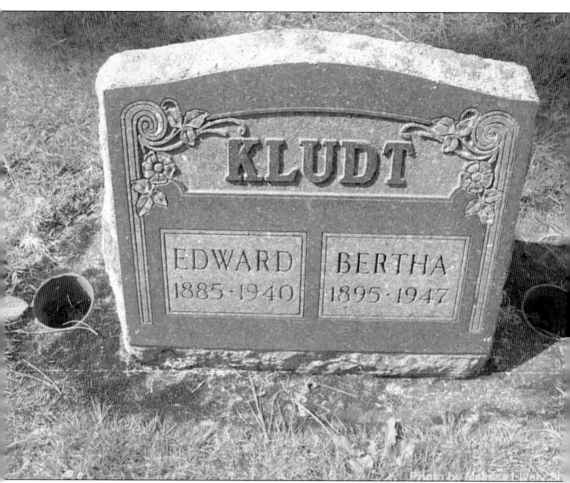

BERTHA KLUDT'S TOMBSTONE. On the night before Halloween 1947, screams filled the air. As neighbors approached, they witnessed a barefoot African American man run from the Kludt house and crash through the fence. The concerned bystanders gave chase and cornered the man until police arrived. Blood and brain matter covered his clothing, as well as the ax and shoes still in the kitchen, near the lifeless bodies of Bertha and Beverly Kludt. Uncertain if it was a robbery or rape gone terribly wrong, police were able to piece together some events from that night. Bertha was killed first, and as daughter Beverly came to her mother's rescue, she faced the ax, too. The mother and daughter were hacked to death by serial killer Jake Bird, who claimed to have killed 46 people. According to what he told police during his confession, his final murders took place at this home in Tacoma. (AC.)

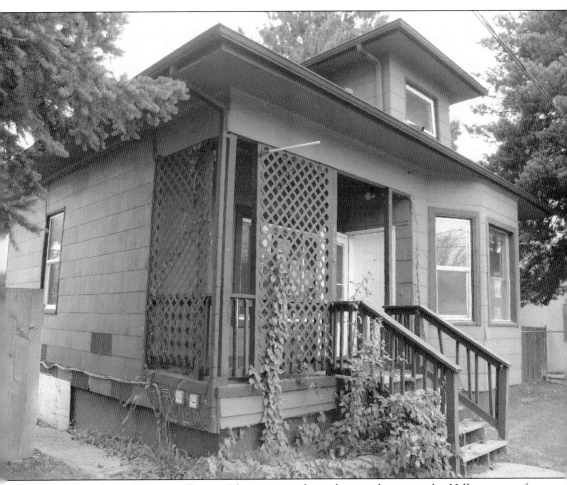

JAKE BIRD'S LAST MURDER HOUSE. This quiet and nondescript home in the Hilltop area of Tacoma holds many secrets. Those passing by would not give it a second look. The faded notices on the windows indicate the home has sat abandoned for several years. Are its ghosts scaring off homeowners? Between Jake Bird's confession and forensic evidence, his trial lasted only two short days. Authorities would not allow Bird to represent himself; therefore, he recanted his confession, pleading not guilty. Just 35 minutes after deliberations began, the jury announced a guilty verdict and sentenced Bird to death by hanging. After his sentencing, Bird made a final statement: "I'm putting the Jack Bird hex on all of you who had anything to do with my being punished. Mark my words you will die before I do." While many laughed at the words of the condemned man, they would quickly learn not to tempt fate. A judge, two police officers who took the confession, a court clerk, and one prison guard died within one month of the sentencing. One of Bird's lawyers died on the first anniversary of his sentencing. It is possible these deaths were a coincidence, but those closely related to the case would beg to differ, if they could speak from the grave. When combined, the originally confessed murders and deaths via hex make Jake Bird the most prolific serial killer in the United States. (WSDA.)

STATE OF WASHINGTON,
County of *Pierce* } ss.

No. 51301

MARRIAGE CERTIFICATE

THIS IS TO CERTIFY, that the undersigned, a *Clergyman*

by authority of a License bearing date the *23rd* day of *January* A.D. 19*32*

and issued by the County Auditor of the County of *Pierce*, did, on the *23rd* day of

January, A.D. 19*32*, at the hour of _____ in the County and State aforesaid, join IN LAWFUL WEDLOCK

John O. Peterson, of the County of *King*, of the State of *Or*

Mabel V. Dybdahl, of the County of *King*, of the State of *Or*

with their mutual assent, in the presence of *Douglas L. Gustafson*

and *Mamie Rebecca Wells*, _____ Witnesses.

IN TESTIMONY WHEREOF, Witness the signatures of the parties to said ceremony, the witnesses and myself, this

23rd day of *January* A.D. 19*32*

WITNESSES	PARTIES	OFFICIATING CLERGYMAN OR OFFICER
Douglas L. Gustafson	*John O Peterson* MALE	
Mamie Rebecca Wells	*Mabel V. Dybdahl* FEMALE	P. O. ADDRESS _____ WASHINGTON

Filed _____ , 19 _____

County Clerk

By _____

Deputy

The person performing the ceremony must fill out this Certificate within 30 days thereafter, and file same with the County Clerk of the County wherein the ceremony was performed; under penalty of a fine of not less than $25.00 or more than $100.00. The County Clerk's Fee for filing was paid at the time the license was issued.

4660

JOHN PETERSON'S MARRIAGE CERTIFICATE. John Peterson had a modest rambling bungalow built around 1910. Francine Pacinda, along with her two daughters and grandchild, moved into the home around 1970, and the hauntings began soon after. Pacinda reported vivid details of terrifying paranormal activity in the home. The family was eager to leave the house once the ominous events had begun, but all of their money was tied up in the home loan and they could not afford to move. Desperate for answers, Pacinda called in a psychic who told the family a death had occurred at the home. Presumably, a husband murdered his wife in the basement. Peterson and his family are the only other recorded homeowners, and the commonality of his name makes research difficult to confirm or deny a murder within the family. When Pacinda died in 1976, the home faced demolition, and a new home took its place. The new home appears void of ghostly inhabitants. (AC.)

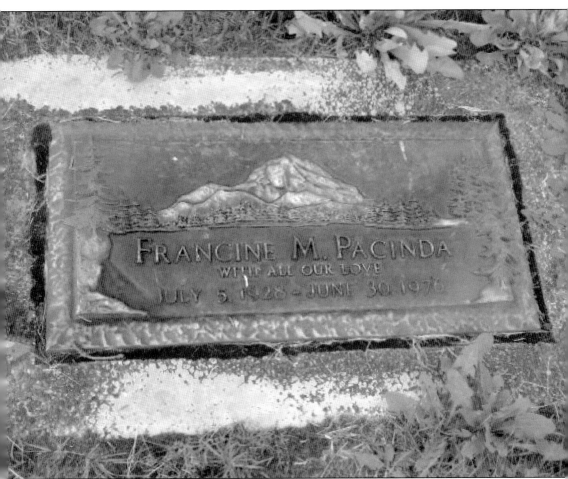

FRANCINE PACINDA'S FINAL RESTING PLACE. In the 1970s, *Tacoma News Tribune* reporter Dwight Farrell came across what would seem to be poltergeist activity when he chronicled this family's encounters, including reports of Pacinda's bedroom door repeatedly opening and slamming shut by some unknown force, lights turning on and off on their own, and moaning sounds filling the dining room at all hours of the night. One encounter involved a woman calling out to Pacinda's daughter, "Come out and help me." When the voice was investigated, there was no one home at the time. They even described hearing someone running up and down the halls late one night when everyone was in bed, fearful of the scratching sounds surrounding them. (AC.)

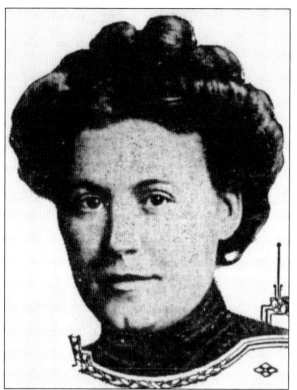

MARTIN AND MARTINA KVALSHAUG.
In 1909, Martin and Martina
Kvalshaug had a cabin in a forested
area. The Kvalshaugs were returning
home from a dance in town when
Charles Newcomb approached. He
struck Martin in the head with a
rock before firing four fatal shots and
fleeing the scene. Martina played the
part of distraught widow until police
questioned her in detail. Apparently,
Martina was romantically involved
with Newcomb, and together, the
two had plotted the devious murder
of Martin. After the trial, the jury
took pity on Newcomb, a husband
and father, and chose a jail term
rather than corporal punishment.
Martina went on trial multiple
times, but accessory to murder
was new to the judicial system and
therefore no clear punishment had
been outlined. Acquitted multiple
times, she remarried, but not to
Newcomb, shortly after the dust
settled. (Left, TNT; below, AC.)

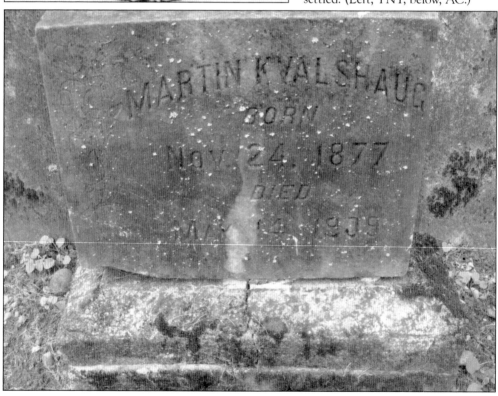

Three

DOWNTOWN TACOMA

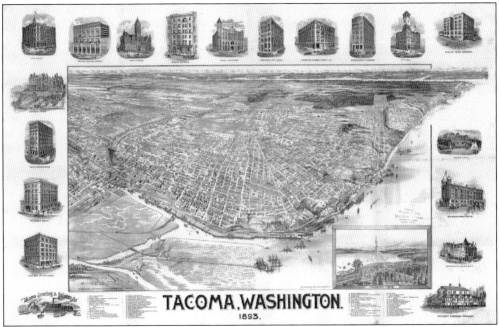

DOWNTOWN TACOMA. Downtown Tacoma is known for its historic buildings, many of which date back to the end of the 19th century. The community continued to grow with expectations of the Northern Pacific Railway's arrival. The railroad had selected Tacoma over Seattle. With the Northern Pacific headquarters located downtown, the area came to life and became the hub of Tacoma. (AC.)

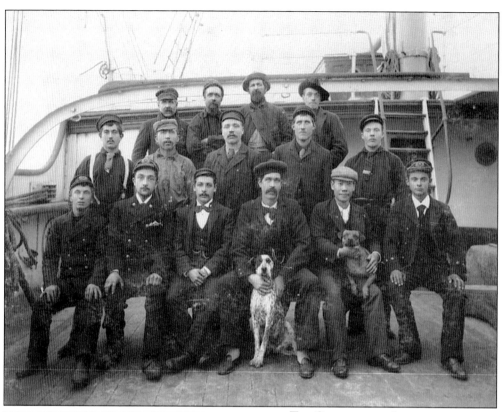

THE CREW OF THE ANDELENA AND A LETTER FROM A SAILOR. The *Andelena* was not the first ship to meet its final resting place in Commencement Bay, and it would not be the last. Moored in the bay just 500 feet offshore on the night of January 6, 1899, the crew bunkered down for the night. There was a storm brewing, and the water was rough. One man went ashore to seek medical attention, but 17 others remained on board. As the wind increased, the lines holding the ship snapped, and the ship vanished into the dark bay, taking with it the sailors who would remain entombed belowdecks. Divers have attempted to raise the ship and recover the sailors' remains, but all attempts have failed. In fact, one diver lost his life during an attempted rescue. (Both, Surnateum.)

LETTERS FROM THE DEARLY DEPARTED. Today, with the help of new scientific devices, scans of the bay reveal a shadowy mass where the *Andelena* and her crew are believed to sleep. On stormy nights in the bay, folks near the shore and on boats passing by have heard the haunting sounds of men yelling, but their screams cannot be deciphered. On one of the expeditions to recover the sunken ship, a diver retrieved a port window from the vessel. Now in the hands of the Washington State Historical Museum, the window is said to reveal the face of a drowning man when peering into the glass at the perfect time. (Both, Surnateum.)

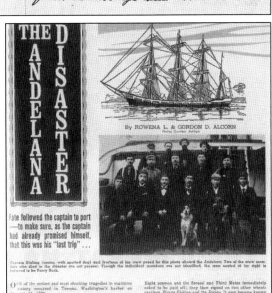

33

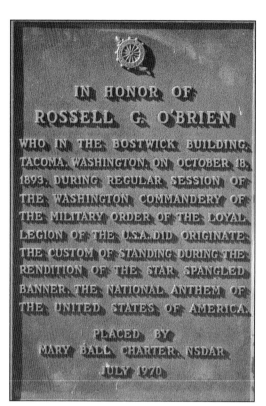

BOSTWICK BUILDING. The home of Dr. Henry Bostwick stood at this location but was demolished in 1889. Here, in 1893, Civil War veteran Rossell O'Brien proposed a resolution that legion members remove their hats and stand during the national anthem; in 1908, the former locksmith in town committed suicide in his room at the Bostwick Hotel; and, in 1927, detectives shot and killed a bandit who was planning to rob the hotel. (LOC.)

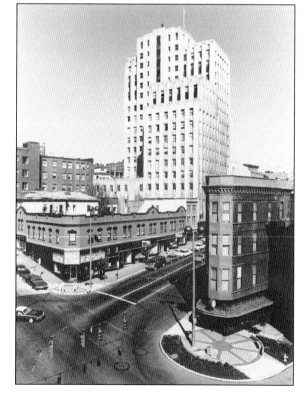

STRANGE OCCURANCES. The Bostwick building is now operated as apartments. The building's coffee shop, Tally's, in the front corner has had its fair share of strange occurrences. The staff has witnessed chairs moving on their own, faucets turning on and off, and a few other items moving as well. It is not certain who is haunting the building, it is just certain that it is haunted. (AC.)

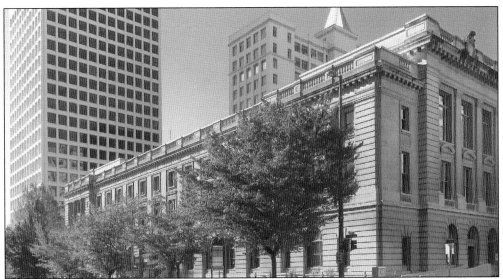

FEDERAL BUILDING. Archibald McMillan built a boardinghouse in 1879. It was demolished in 1907, and the current building was constructed in 1910. After construction of the Federal Building, this site held a swarm of FBI activity, as it was used for their meetings while in town. The bottom floor served as a post office, and the top floor provided office space. Rumors state a federal judge died in his quarters upstairs. (AC.)

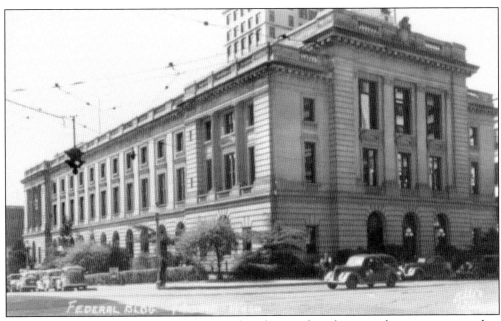

A JUDGE REMAINS. Today, many of the postal workers working late into the evening swear they can hear someone walking around upstairs when the building is closed for the night. They also talk about hearing a door open and close. When anyone is brave enough to investigate these disturbances, no living soul is found to have caused the noises. Several believe it is one of the old judges, unaware he has passed on. (LOC.)

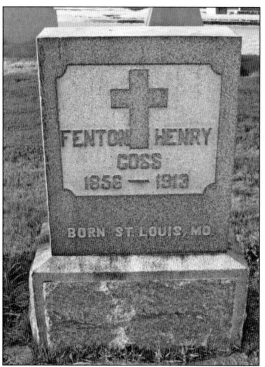

FENTON GOSS'S SUICIDE. Fenton Goss, president, manager, and sole owner of Goss Brick Company, disappeared from his home on January 15, 1913, followed by the newspaper headline "Fenton H. Goss a Suicide: Despondent Blows His Brains Out." Possibly distraught over losing the bid for the Central School, Goss killed himself by placing a .32-caliber revolver in his mouth and pulling the trigger while looking in the mirror. (AC.)

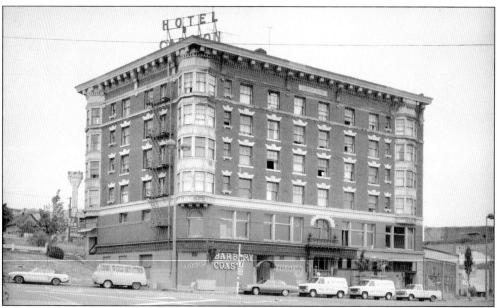

CARLTON HOTEL. Hotel owner Anton Huth named his establishment after his son Carlton. Catering mostly to railroad passengers, the hotel boasted 120 rooms, with a select few offering private baths. The hotel was later renamed the Earle Hotel when new owners took over. Today, it serves as offices, including those of the University of Washington Tacoma. One tenant, however, still roams the halls of the old hotel. The sound of footsteps and that of doors opening and closing reverberate through its empty corridors. Many believe it is Goss, having not passed on after regretting his final moments of life. (LOC.)

ELKS LODGE. Before the Elks Lodge No. 147 arrived in 1916, this site held the St. Charles Hotel from 1880 to 1914. The Elks moved out in 1969, and the building became abandoned. Designed after the Scala di Spagna of Rome, its beautiful Spanish steps served as a fire escape but would claim the life of one man in 1984. (AC.)

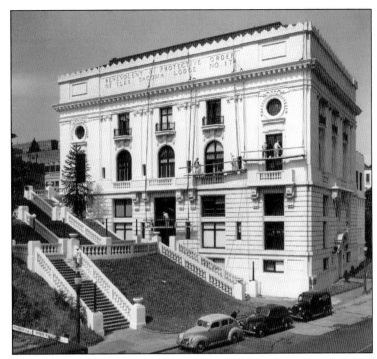

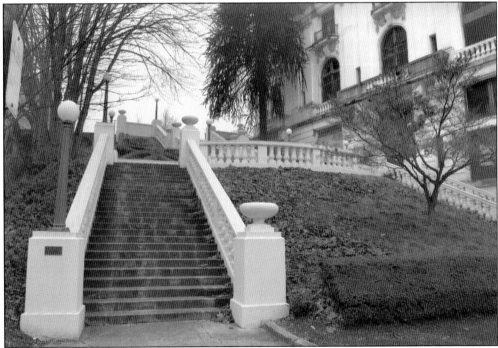

SPANISH STEPS. The saddest thing about this structure is the fact that what was once a favored destination for the city is now an eyesore. Rotting away to almost extinction, the building has yet to find new life; however, its empty shell still echoes with the sounds of laughter, singing, and footsteps. Those who are brave enough to venture inside these crumbling walls might catch a glimpse of a male figure from the corner of their eye, but just as they turn to make contact, no one is there. (AC.)

PEOPLE'S STORE. While the address has changed, the building remains the same. Built in 1890, this structure first operated as the People's Store. It later changed hands a number of times, hosting a lumber company, furniture store, commercial truck company, and even a Sears, Roebuck & Company store. Today, the building serves as classroom space for the University of Washington's students. Annie Clark committed suicide at the Gandolfo Hotel, which was located nearby. (LOC.)

CREEPY CAMPUS. Students feel the upper floors have a bit of paranormal activity. Most recount the distinct sound of high heels, but no woman has ever been seen where the clicking seems to be coming from. Papers were once thrown off a desk, and chairs have been known to move without assistance. Who is this woman that haunts these floors? Some believe it could be a former secretary who worked in the building long ago. (AC.)

DEATH CERTIFICATE FOR ALEXANDER PARKER. Constructed in 1887, the Roberts-Parker Building was a joint effort between Samuel Roberts and Alexander Parker. During its history, the building has housed a grocery store, confectionery shop, tea company, shoe store, jazz club, apartments, and several restaurants. On October 12, 1968, a man shot and killed three people along the sidewalk directly in front of Siri's Restaurant, the building's current inhabitant. A few years later, a man died from burns received in a fire. (LOC.)

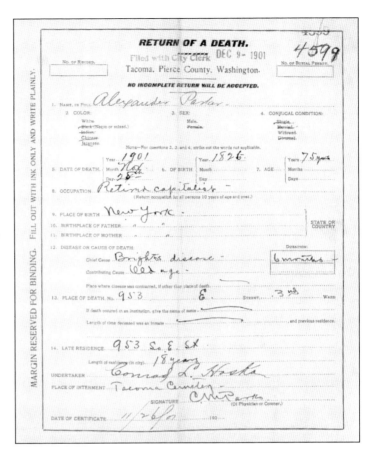

THOMAS "RED" KELLY. Thomas "Red" Kelly ran the popular jazz club and restaurant with such great pride back when it was known as Kelly's. Unfortunately, he had to close the club in 2003 and then died a year later. Some believe his ghost lingers throughout the building, still playing that lovely and mysterious jazz music that folks tend to hear. Today, however, things seemed to have quieted down, possibly due to the new owner playing jazz in her restaurant. Maybe this makes Red feel right at home. (WPB.)

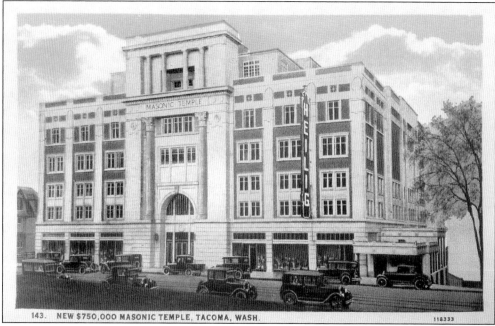

143. NEW $750,000 MASONIC TEMPLE, TACOMA, WASH. 118333

MASONIC TEMPLE AND TEMPLE THEATRE. The splendid residence of Eben Pierce was built in 1888, but it was later demolished to make room for the Masonic Temple. Pierce was a prominent settler in Tacoma who played a large roll in its history. He passed away in 1907. Built in 1927, this building opened as the Masonic Temple with a small theater attached. The Masons are a research society of Freemasonry. The Freemasons are one of the most secretive and controversial religious groups around the world. It is possible that their secret rituals have brought forth spirits that are unwilling to rest. In 1972, a faulty elevator crushed and killed the janitor of the Temple Theatre. (Both, AC.)

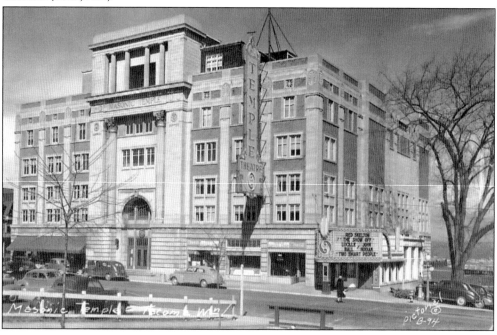

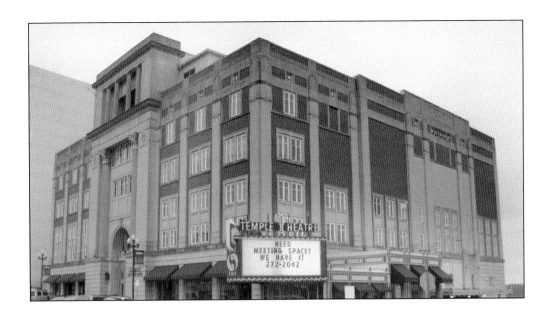

CHARLIE THE JANITOR. It is believed that the janitor's ghost, known as Charlie, now resides here as a glowing apparition seen in the upper balcony. In addition to the elevator that seems to have a mind of its own, stopping at random floors or opening and closing at will, employees have heard furniture moving across the floors and seen glowing lights from time to time. In the temple, there have been sightings of a man in a robe near the windows and the front door. (Both, AC.)

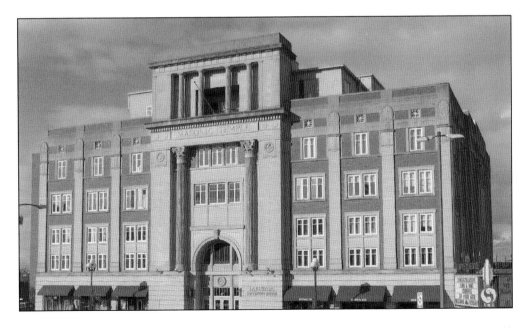

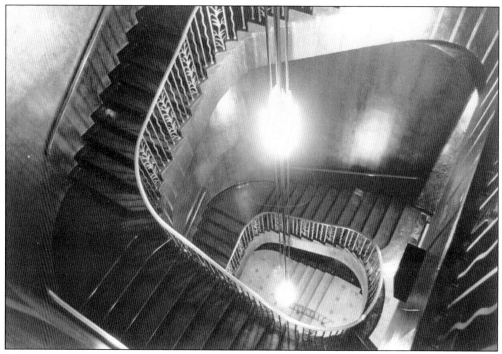

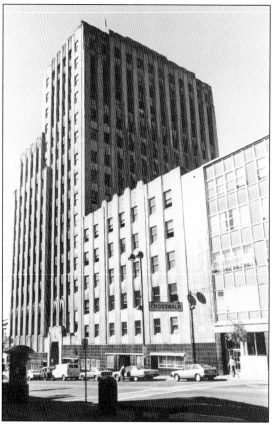

MEDICAL ARTS BUILDING. The Medical Arts Building is newer than many in the downtown area. Built in 1930, it reaches 17 stories in height, making it the tallest building in Tacoma. In 1940, Michael Brandt leaped to his death from a fire escape on the 17th floor, landing on the roof of the 4th floor. A truck driver for the local bakery, Brandt left a note stating he was despondent. (LOC.)

GHOST LINGERS IN THE HALLS. There is a man who has been haunting this place for years. He is believed to be a smoker, because when strange things seem to happen, the distinct smell of cigarette smoke lingers in the air as well. He has been seen throughout the building and heard pacing back and forth, perhaps contemplating his final decision to end his life. In the field of ghostly phenomena, it is a common belief that those who commit suicide become trapped at the site of their death. Whether due to regret or some spiritual attachment to the property, locations that have had a number of suicides tend to be extremely haunted. (LOC.)

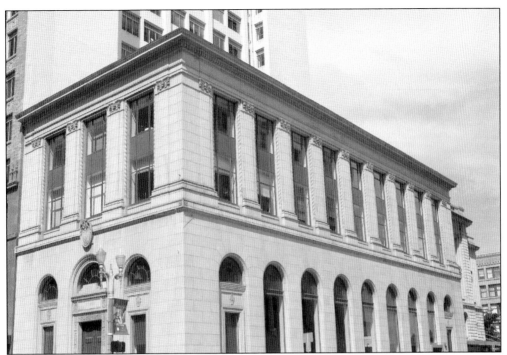

NATIONAL BANK OF WASHINGTON. Constructed of Wilkeson sandstone in 1921, this Italian Renaissance building was first known as the National Bank of Tacoma, the president of which was Chester Thorne. Reports detail a tunnel traveling under the bank but do not disclose where it terminates. The building would become the Tacoma Art Museum, then the Asian Pacific Cultural Center, and finally, the practices of several doctors. (WSDA.)

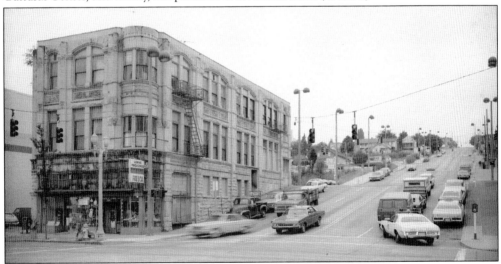

WAITING FOR THE MARKET TO TURN? During the stock market crash of 1929, a failed banker shot himself in his third-story office. When the art museum was located here, an employee experienced an odd encounter while walking the halls of the third floor after closing; she nearly bumped into a man in a 1920s suit. She turned in his direction, only to witness him vanish before her eyes. Many feel his presence and hear him walking around. On some occasions, guests and staff have reported hearing loud banging sounds coming from upstairs that stop when investigated. (LOC.)

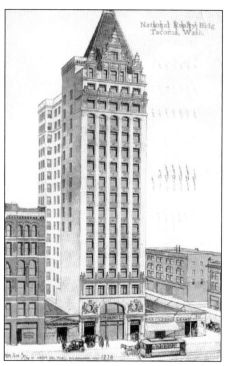

CRUSHED. In 1910, the tallest building on the West Coast came to life. In 1915, a young man by the last name of Andrews fell 13 floors down the elevator shaft to his death. As he stepped off the elevator, the cage gave a jerk upward, throwing him off-balance and tossing him down the shaft. Reports indicate that he broke nearly every bone in his body on impact. (AC.)

ARE YOU AFRAID OF ELEVATORS? Accidents do happen, but that does not mean they always lead to a haunting. People die everywhere, in residential and commercial properties. However, in cases where it may have happened quickly, these departed souls may not be conscious they have passed on. Here, they go about their business and keep bumping into the living. Could this explain why this location has an elevator that seems to have a mind of its own, stopping at empty floors, opening the doors when no one has called for it, and exuding that eerie feeling of not being alone? Is Andrews unaware of what has happened to him? (TPL.)

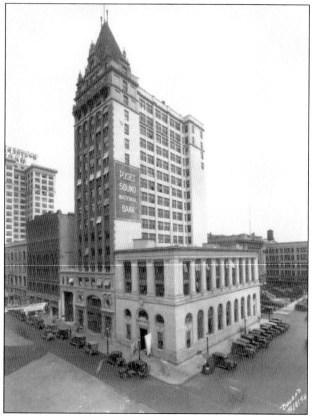

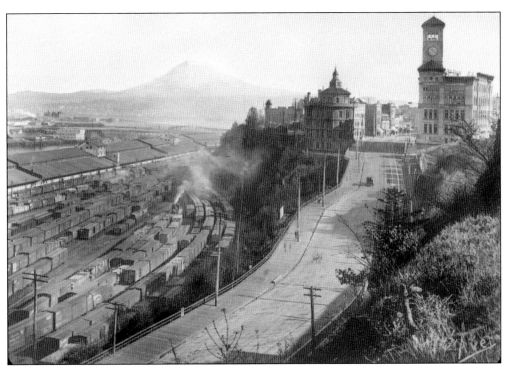

NORTHERN PACIFIC RAILWAY. Built in 1887, this building was the spotlight of the Northern Pacific Railway and Tacoma's small claim to fame. Paul Schulze, land agent for the railroad, committed suicide in his home in 1895. As the era of railway passed, the building took on new responsibilities. In 1929, the south wing of the building was demolished to make way for a jail. Then, in 1954, Alice Shisler was found dead in her cell; she had tied a scarf around her neck and fastened it to the doorknob. At least one more suicide would take place at this location before it was again demolished in 1974. (LOC.)

NATIVE AMERICAN HAUNTING. The small park next to the building is rumored to have a sacred stone beneath its soil, once a Native American burial ground. Whether this claim is true or not, the property still has ties to a death that took place in the south wing of the structure that once stood at this site. It is said that many unexplained events had haunted the former building. Whatever happened there seems to still occur within these gardens, including sightings of an obscure male figure walking across the park, until he blends into the surrounding shadows, and a streetlight that greets visitors by blinking hello when someone passes by it. (AC.)

Department of Health of the City of Tacoma.

CERTIFICATE OF DEATH

Filed with City Clerk
OCT 26 1899

1—Full Name : *Julia Ambler*
2—Age — *38* — years, —*9*— months, ———days.
3—Sex: ~~Male~~, Female. 4—White, ~~Colored~~
5—~~Single~~, Married, ~~Widow~~, ~~Widower~~.
6—Birthplace *France* 7—Occupation *Housewife*
8—If of foreign birth, how long in the U.S._____years 9—How long resident in the City_____years
10—Father's Birthplace *France* 11—Mother's Birthplace *France*
12—Place of Death, No *1008 Asotin St.* Tacoma, Ward *3rd*
13—I HEREBY CERTIFY that I attended the deceased from _____189__ to _____
189____ that I last saw h____ alive on the _____ day of _____189__ : that __he died on the
27th day of *Sept* 189*9*. about *6* — o'clock ~~A.M.~~, or P.M., and that the following was the
14—Cause of death: Time from Attack till Death
I *Pistol shot wounds in the back.*
II

This Certificate, Delivered to *C. L. Heyska* _____ at _____ M., _____189__
Signed by *Omar L Hysta* M.D. No _____ Street or Avenue
Medical Attendant *Coroner* Address

Midwives must report, in person, all Still Births, within twelve hours.

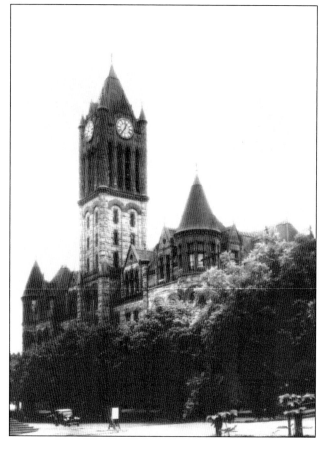

PIERCE COUNTY COURTHOUSE. In 1896, Albert Michaud entered the Fannie Paddock Memorial Hospital with the intent to kill his wife, Julia, while she worked as a nurse. He went to jail, during which time Julia moved on. Released in July 1899, Albert became enraged when he learned of Julia's new marriage. On the evening of September 28, 1899, around 6:00, Albert arrived at Julia's residence. She tried to run away, but he fired on her at close range, discharging the fatal shot. He then turned the gun on himself, putting it in his mouth and pulling the trigger, but it malfunctioned. When people began crowding the streets and shouting in horror, he attempted to escape, but he was captured. On April 6, 1900, Albert was hanged from the gallows. Supposedly, at the time of his arrest, his hair was jet black, but by the time of his hanging, his hair had turned pure white from the fear of dying on the gallows. (Above, AC; left, TPL.)

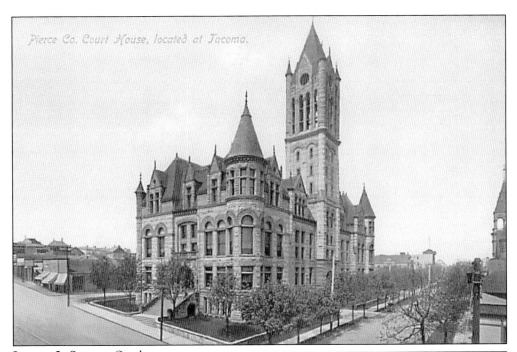

Pierce Co. Court House, located at Tacoma.

JUSTICE IS SERVED. On the evening of February 10, 1900, around 6:00, Eben Boyce went to the Domestic Bakery on Tenth Street and killed his wife, his anger stemming from the sale of his prized trombone. On the night of the murder, Eben had drunk heavily, and when he opened the door to the restaurant in which his wife worked, she noted the look on his face before screaming in terror. He opened fire and shot three times, shattering her arm and chest. He left her in a pool of blood and crying out for help. The sound of her labored breathing still lingers. On August 9, 1901, talented musician Eben Boyce stood on the scaffold and stated, "I am a soldier still." Moments later, his neck broke and his heart ceased during his execution on the fifth floor of the courthouse. (Both, AC.)

RETURN OF A DEATH.

Filed with City Clerk
Tacoma, Pierce County, Washington.

NO INCOMPLETE RETURN WILL BE ACCEPTED.

1. Name, in full: *Eben Boyce*

2. Color: White. Black (Negro or mixed). Indian. Chinese. Japanese.

3. Sex: Male. Female.

4. Conjugal Condition: Single. Married. Widowed. Divorced.

NOTE.—For questions 2, 3, and 4, strike out words not applicable.

5. DATE OF DEATH: Year *1901* Month *Aug* Day *9*

6. OF BIRTH: Year Month Day

7. AGE: Years *38* Months Days

8. OCCUPATION: *Musician*

9. PLACE OF BIRTH: *Michigan*

10. BIRTHPLACE OF FATHER: *New York*

11. BIRTHPLACE OF MOTHER: *Ohio*

12. DISEASE OR CAUSE OF DEATH: CHIEF CAUSE *Hanged* CONTRIBUTING CAUSE *by legal execution* DURATION *Instant*

Place where disease was contracted, if other than place of death.

13. PLACE OF DEATH, No. *County Court House*

If death occurred in an institution, give the name of same.

Length of time deceased was an inmate.

14. LATE RESIDENCE. *County Court House*

Length of Residence (in city)

UNDERTAKER. *J. L. Roberts Jr.*

PLACE OF INTERMENT. *County Cemetery*

DATE OF CERTIFICATE. *Aug 17* 19 *01*

47

TACOMA'S MOST HAUNTED CLOCK TOWER. As a growing city, Tacoma needed a site for its city hall. In 1893, the Italian Renaissance–style building was constructed. Only six stories high, this building remains one of the most spectacular in town, marked by its majestic clock tower. In 1904, Hugh and Mildred Wallace donated the bells for the clock tower in honor of their young daughter Mildred, who passed away while they were traveling overseas. Although the building has been abandoned for many years, the city hall holds only one mysterious death involving a rope in November 1939. First believed to be a suicide, it was eventually discovered to be an accident. (Both, WSDA.)

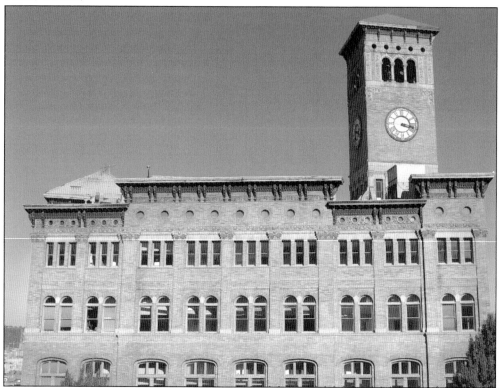

THE BELLS STILL TOLL. If you were to ask any stranger within the city limits where to find a haunting in Tacoma, be assured many would direct you to the old city hall. For several years, reports of the bells ringing in the tower have been documented. The strange thing is the bells have been disconnected for years. Some say it is Mildred herself, roaming the clock tower. Convinced it was someone fooling around with the bells, manager Jim Brewster spent the night, only to discover he was not alone when he encountered strange shadows and noises. There is also a ghost named Gus who loves to fool around on the first floor. When the Clock Tower Restaurant was open, the staff had issues with Gus throwing dishes and wine bottles. In 2002, AGHOST Investigations spent the night capturing evidence of ghostly voices and photographs of a shadowy figure in a hat lurking near the old jail cells in the basement. (Both, AC.)

SANFORD & SONS. Built in 1904, the Sanford & Sons Antiques building previously housed a number of tenants, ranging from metalworks to Cadillac parts and repair. While it went through many owners, they all ran automobile repair shops until 1939, when Broadway Bowling Alley came to life. On February 23, 1956, barber and retired World War II sergeant William Baranko ended his own life with one shot inside this building. (AC.)

DEATH OF WILLIAM BARANKO. There is the popular belief that spirits can attach themselves to a person, place, or thing. So when it comes to antiques, various folks feel ghosts may possess these objects as well. Throughout the years, this place seems to have experienced a number of unusual incidents. Here, strange noises are heard after closing. Things disappear and show up in strange places. Lights turn on and off by themselves. Customers and employees encounter cold spots that cannot be explained. While it might be spirits coming and going with the antiques, it could very well be Baranko himself. (Melissa Sherry.)

KNIGHTS OF PYTHIAS TEMPLE. Founded in Washington, DC, in 1864, the Knights of Pythias is a fraternal organization and secret society. The lower floors of the Pythian Temple were previously rented out to stores and businesses, and the upper floors were reserved for lodge use only. One feature unique to this building is the preservation; the carpets, furniture, windows, and interior decor date back to when it was constructed in 1906. The temple prides itself on preserving history. (AC.)

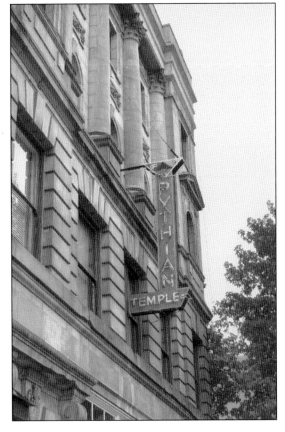

HAUNTED HALLS. In what was once a thrift store on the main floor, the owner was in the back room working late into the night when she heard the sounds of partying going on on the upper floors. This carried on for a few minutes, until she investigated and realized there was no one upstairs. While members of the Pythian claim to not recall any strange activity on their floors, they do cling to their past, as evidenced by all the furnishings that date back to the temple's early days. On Mondays, they do open their doors to the public for a tour of the grand building they call home. (AC.)

ABE GROSS FOUND DEAD ON THE LAND WHERE THE JONES BUILDING STANDS. On March 30, 1895, Abe Gross was found dead in his apartment on the upper floor of the Gross Building. The pillow where his head rested was saturated in blood, as were his lower face and neck. Gross had a habit of arriving to work early, so when he did not show up, his brother Morris went to his apartment. Morris grabbed his brother's cold, limp hand, slung over the edge of the bed, and kissed it. Rumors quickly spread around town. Some said it was suicide, or an accident, or even murder. After performing a quick search, the coroner determined that the muzzle of the weapon had been placed in his mouth and that the bullet was lodged in his head. No suicide note was found. Gross was a popular man in town, and people were quite upset by his untimely death. (Left, AC; below, LOC.)

PANTAGES THEATER. Alexander Pantages dreamed of owning majestic theaters all over the country. With the help of his business partner, William Jones, he created a building with a theater on the lower level and business offices on the upper levels. Pantages utilized the financial backing from his mistress, Kate "Klondyke" Rockwell, to fund the project. Kate was a beautiful woman and talented dancer who held the key to Pantages's heart. (Both, LOC.)

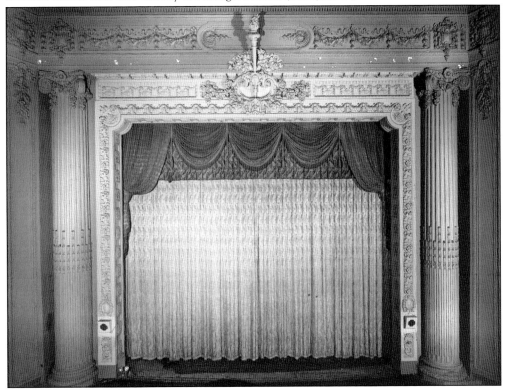

WHO HAUNTS THE PANTAGES? Not long after the opening of Pantages Theater, the lovely sex goddess Mae West danced across this stage, and some feel she might still dwell here. A woman in a long red dress has been seen walking across the dimly lit stage when the theater is empty. One young actress claims that her nerves were out of control while getting ready for her first show when an older blonde woman with long false eyelashes and heavy makeup approached her backstage to offer advice: "Relax, kiddo. The audience is here to have a good time. They'll love you if you just give them a wink and a smile." There is also a man in a tuxedo who appears in the seats, then vanishes upon being noticed. Near the stage is a large carving of a face that is thought to be Pantages himself. According to numerous accounts, if he is not pleased with the show, his distaste is reflected in his facial expression. (Both, LOC.)

Perkins Building. The first building at this location was erected in 1890, while the Perkins Building was not constructed until 1906. At one time, the building held the Hotel Hauser and Dawson Saloon. In 1901, a man was found to have killed himself in the hotel with his own knife. It remains unclear whether his death was due to suicide or murder. The Perkins Building was named for Sam Perkins, publisher and founder of the local newspaper. (AC.)

The Perkins Building. Tacoma, Wash.

Shy Spirit. Now the building houses condominiums for the living, but what about the dead? There is not much paranormal activity to speak of in regard to this historic building. What does linger in the shadows seems to shy away and keep to himself, but every so often, eyewitnesses have seen a male figure. When this space still functioned as a hotel, the cleaning staff heard a man crying in one of the room's closets, but when they opened the door, no one was inside. Could this be the man who was killed with a knife attempting to tell his story? (AC.)

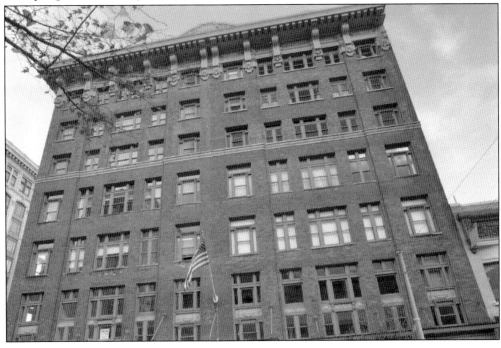

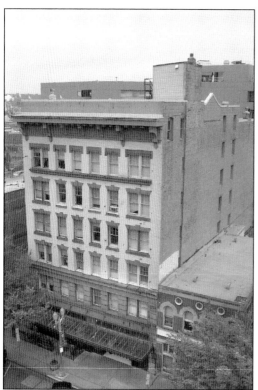

OLYMPUS HOTEL. Built in 1909, the Olympus Hotel was often threatened with closure due to lack of money and shady dealings. In December 1914, J.M. Norton died from a fatal seizure in his hotel room. He had cried for help, but it arrived too late to save him. Samuel Percival, a Tacoma pioneer, passed away suddenly from heart failure in the hotel lobby in 1942. In December 1996, Evan Hunziker, a former North Korea captive, took his own life inside the hotel. In 2004, the hotel became low-income housing. (AC.)

SPIRITS OF MANY KINDS. Said to have ties to the mob, the Supper Club was housed in the basement, where quite a few men were beaten to death with bats. Even before the Olympus Hotel, it carried a bad reputation as the Theatre Comique and gambling hall, run by Harry Morgan, a man who controlled just about anything illegal, even the local police. So finding a troublesome spirit here would seem fitting. Many report strange sounds, animated objects, and disembodied voices on the lower levels. (TPL.)

BODEGA SALOON. Those looking to drink, gamble, or partake in illegal activities could visit the Bodega Saloon, built in 1889. The City of Tacoma made many attempts to close down the seedy establishment, where women abided in the hotel rooms upstairs, having drinks and men sent to them. Tunnels were discovered running under the building and down to the bay through which young men were shanghaied and sent off to sea against their will. (AC.)

EVIL STILL LURKS. With its nasty history, it is not hard to believe that the Bodega Saloon is haunted. The air is heavy, and the presences are felt immediately upon walking in the door. The women were treated like slaves, and the young men became them. With so much negativity here, these souls are truly not at rest, from a young woman crying to the sounds of bar fights in the middle of the night. Here, the shadows love to play tricks on you by moving things around, making you feel dizzy, and turning off the lights when you need them most. (AC.)

R. L. POLK & CO's

THE BODEGA,

No. 709 Pacific Ave. Tel. 506. C. C. PAGETT, Jr. & CO., Props.

Wholesale and Retail Dealers In

Wines, Liquors and Cigars.

Bodega Bar Connected, also Reading Rooms and Private Apartments for Gents.

Family Trade a Specialty. Free Delivery Inside of City Limits.

Sole Agents for and Bottlers of

WM. J. LEMP'S CELEBRATED ST. LOUIS LAGER BEER.

THE AVENUE SALOON.

No. 911 Pacific Avenue.

BEST BRANDS OF

Wines, Liquors and Cigars,

C. C. PAGETT, Jr. & CO., Props.

THE BODEGA No. 2.

No. 1407 Pacific Avenue, C. C. PAGETT, Jr. & CO, Props.

LEADING BRANDS OF

Wines, Liquors and Cigars.

CALL FOR

LEMP'S CELEBRATED ST. LOUIS LAGER BEER,

ALWAYS ON TAP.

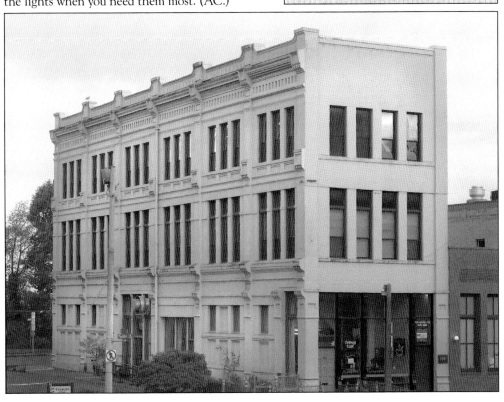

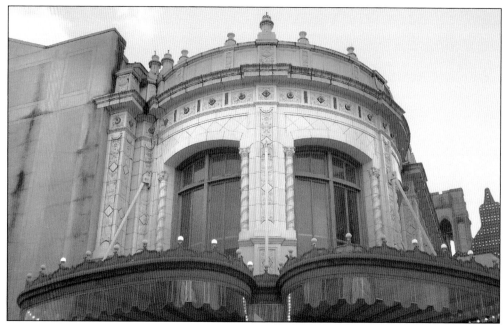

RIALTO THEATER. Unlike its close neighbor the Pantages, the Rialto Theater was built for showing movies, not performances; however, it is currently used for live performances. The Florentine Italian Renaissance building was constructed in 1918. Rare independent movies as well as popular Hollywood movies have been shown at the Rialto. Movie stars have also made personal appearances at the theater. (Both, AC.)

GHOSTS PERFORM NIGHTLY.
Every good theater has its
ghosts, so why would this one
be any different? Theaters seem
to hold on to what the actors
put into them with great love
and devotion. Some dreams are
never fulfilled, and the range of
human emotions expressed on
the stage can echo on forever,
leaving behind that residual
performance. The Rialto seems
to have a male figure lurking
in its upper balcony during
rehearsals, when there should
not be anyone else in the theater.
Other occurrences involve
unexplainable disturbances
during performances and props
disappearing and showing up
in odd places or just in plain
sight. (Right, AC; below, TPL.)

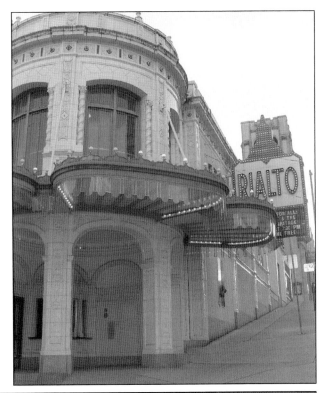

TACOMA'S ARMORY. Constructed in 1908, the armory of the Washington National Guard originally contained horse stalls, a shooting range, and a swimming pool. The doors opened on New Year's Eve, 1909, for a military ball. When President Taft visited in 1911, a large crowd gathered to receive him. King Olav of Norway, then the crown prince, spoke at the armory in 1939. In 1952, President Nixon visited. In 1989, sections of the building were converted to jail cells to alleviate the problem of overcrowding at the facility next door. For a few years, this gentle giant remained abandoned until it was purchased in 2013 with hopes of historical restoration. (Both, WSDA.)

State Armory, TACOMA, Washington.

A HAUNTED FORTRESS. The brick structure of the armory is reminiscent of a traditional haunted castle, with its tower and massive facade bearing down upon you. Through the years, many who have worked here or even stayed here have experienced a strange thing now and then. Most folks discuss hearing voices or footsteps when no other living person is around. Doors open and close, while lights and water turn on and off. There have been sightings of a young man in military uniform, but when seen, it is just a glimpse of him as he walks through doors or around a corner. (Both, AC.)

JULY 4, 1900. On July 4, 1900, over 100 passengers crowded on board a streetcar heading to the holiday festivities. The conditions were wet, and when the car descended the hill on Delin Street, it picked up speed. The trolley driver was blamed for exceedingly high speeds, as he had been warned about this particular corner and the dangers of approaching it at an excessive speed. Others felt the added weight of the overcrowded car had caused the accident. When it was obvious the car was not slowing down as it quickly approached a sharp curve, many passengers jumped off the moving streetcar. Near the intersection of South Twenty-sixth and C Streets, the tracks headed north via a trestle. (AC.)

3742

RETURN OF A DEATH.

No. of Record.

No. of Burial Permit.

Tacoma, Pierce County, Washington.

NO INCOMPLETE RETURN WILL BE ACCEPTED.

1. Name, in full, *Alvin L. Healy*

2. Color:
 White.
 Black (Negro or mixed).
 Indian.
 Chinese.
 Japanese.

3. Sex:
 Male.
 Female.

4. Conjugal Condition:
 Single.
 Married.
 Widowed.
 Divorced.

Note.—For questions 2, 3, and 4, strike out words not applicable.

5. Date of Death: Year *1900* Month *July* Day *4*

6. Of Birth: Year *1880* Month *Dec* Day *2nd*

7. Age: Years *19* Months *7* Days *2*

8. Occupation *Iron Worker*
 (Return occupation for all persons 10 years of age and over.)

9. Place of Birth *Iowa*

10. Birthplace of Father *Vermont*

11. Birthplace of Mother *Maine*

12. Disease or Cause of Death: Duration

 Chief Cause *Street Car accident*

 Contributing Cause

 Place where disease was contracted, if other than place of death.

13. Place of Death, No. *N E Line Street Bridge Tacoma* Street, *4th* Ward.

 If death occurred in an institution, give the name of same,

 Length of time deceased was an inmate, and previous residence,

14. Late Residence *Lake View — Wash.*

 Length of Residence (in City)

 Undertaker *C L Hoska*

 Place of Interment *Gravelly Lake*

 Signature *Conrad L. Hoska*
 (of Physician or Coroner.)

 Date of Certificate, *July 7* 19 *00*

Worst Streetcar Disaster in the State. The streetcar plummeted over 100 feet into the ravine, taking its unfortunate passengers with it. Witnesses to the accident rushed to help survivors. A nearby pumping station became a makeshift morgue for the 43 souls who perished in the accident, and local hospitals were inundated with injured and critical patients. Local newspapers sensationalized the scene at the hospital wards, describing the degree of injuries to each victim. The jury found motorman F.L. Boehm guilty of causing the accident by starting down a long and dangerous grade at an excessively high rate of speed, then losing control of the streetcar. (WSDA.)

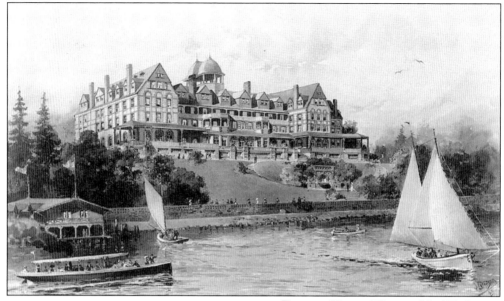

TACOMA HOTEL. This modified Tudor hotel stood as a measure of confidence for the men who believed the railroads would keep Tacoma thriving. Open from 1884 to 1935, the hotel was short-lived, destroyed by an uncontrollable fire and reduced to ruins. No lives were lost during the fire, but there was an obituary in the paper: the Tacoma Hotel, dead at 51. (WSDA.)

POOR JACK IS DEAD.

Taxidermists Will Mount Him—Policemen May Eat Him.

Edwards Brothers, the taxidermists, were employed last night to kill Jack, the Tacoma hotel bear, and prepare his skin for mounting. Poor old Jack will soon appear in effigy at the hotel, as the Edwards Bros. have been employed to mount him.

Yesterday Steward Kelly of the hotel declared he would prosecute the man who shot Jack, he didn't know under what law, but if there wasn't any other he would prosecute him for shooting game out of season.

Inquiry at the Tacoma hotel elicited this reply:

"There may be a barbecue to which all the Tacoma policemen will be invited, but none of Jack's flesh will be eaten at the Tacoma hotel. We do not eat our friends here.

Today circulars were distributed as follows:

ANOTHER

BEAR BARBECUE

AT

JACK THE BEAR. Jack the Bear became the mascot of the hotel around 1890. An orphaned cub, he was raised by the hotel staff. Jack was known to sit at the bar like a man, drinking beer from a mug without spilling it. One fateful day in 1892, however, a police officer shot and killed Jack, mistaking him for a wild bear on the prowl. Citizens mourned his death with a funeral and bear steaks served that night. (TDL.)

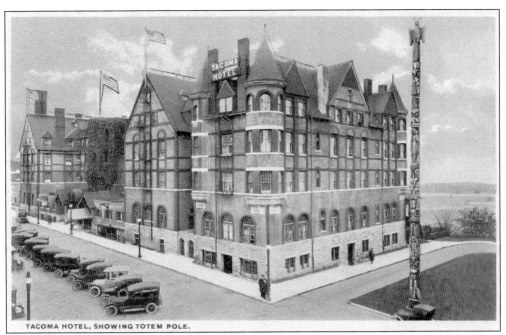

TACOMA HOTEL, SHOWING TOTEM POLE.

BURNED TO THE GROUND. This once massive hotel is truly a lost gem for the city of Tacoma. There is not much to tell when it comes to ghostly haunts at this location. If not haunted by the souls of those who walked its halls, the city is haunted by the loss of the great icon of the Tacoma Hotel. Nonetheless, the spirit of Jack the Bear is believed to still wander the grounds, near the old totem pole that stands nearby in Fireman's Park. (Both, AC.)

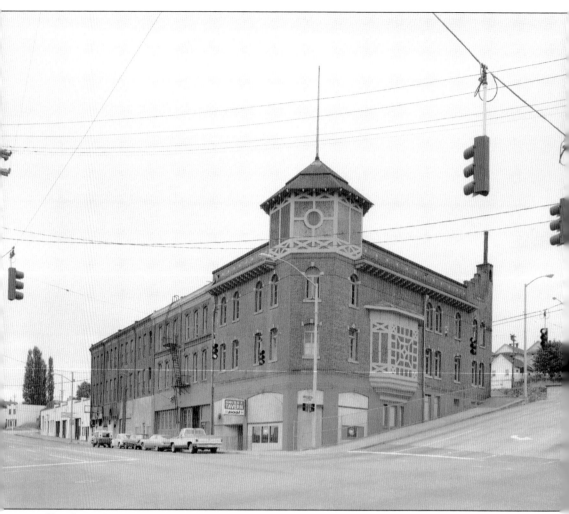

THE SWISS SERVES SPIRITS. The Swiss Hall was constructed in 1913. Its occupants included the Perkins Hotel, Swiss Society, Llewellyn House, Jefferson Hotel, and Carlisle Beverage Distributors. In 1902, a man came into the area, which held a cigar stand at the time, and shot his wife, then himself. On April 24, 1924, Fritz Berning, a rejected suitor, killed Albertine Otto, age 27, at the Jefferson Hotel. The daughter of hotel proprietor Jacob Otto, Albertine had met Berning in California, where he asked her to marry him, but she refused. She returned to Tacoma, and he followed. He went to her room at the hotel and knocked on the door. When she answered, he fired multiple shots without warning. A guest of the hotel said she fell to the ground, and Berning fled the scene. He was later captured in King County. (AC.)

OTTO FAMILY. It seems this area has had its share of death. In fact, the owner of the Swiss Hall, Jack, tells the story of a large man named Big Andy who claimed to have shot and killed his brother-in-law just outside the men's restroom in 1944. With so much bloodshed on these grounds, it would be hard to avoid a few disturbances from the ghostly realm. The staff feels a strange presence near the kitchen area. Bartenders hear strange noises throughout the night. Who are the ghosts? You just might have to swing by the Swiss and find out for yourself. (Both, AC.)

UNION STATION. The grand opening for Union Station took place on April 30, 1911, and the last train traveled through in 1984. This station was the hub for the Northern Pacific Railway and all the travelers coming in and out of Tacoma, as well as the cargo carried by the trains. The railroad was coveted in Tacoma because of its rank over Seattle, and Union Station was the place to visit. (LOC.)

FAMOUS ARCHITECT DIES. Architect Augustus Warren Gould dropped dead from heart disease at Union Station in 1922. Gould designed many of the prominent buildings that still stand in Seattle today. The Arctic Club, Hotel Georgian, and King County Courthouse are just a few of his creations. (LOC.)

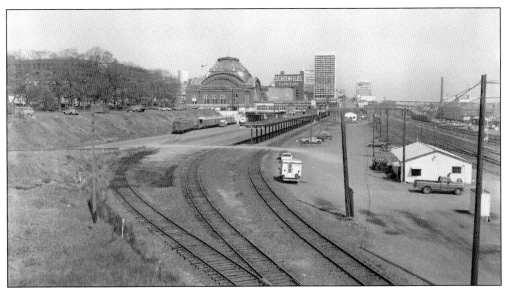

THE TRACKS REMAIN. The last train to depart Union Station was a passenger train on June 14, 1984, leaving this building abandoned until 1992, when it reopened as the courthouse of the US District Court for the Western District of Washington. Here, many employees and visitors have had strange things happen to them. Most of the activity occurs at night, when the security guards are the only living souls around. A woman in a blue Victorian dress is rumored to stroll through the building, mainly on the upper balcony of the main entrance. One guard heard an "excuse me" from behind him, and when he turned, she had vanished. Doors are heard opening and closing, but when security goes to investigate for intruders, no one is ever found. They even hear the sounds of men's shoes walking the empty halls, the apparition of which has been seen carrying a briefcase and wearing a bowler hat. Some believe this could be Gould himself, checking on this grand historic structure. (Both, AC.)

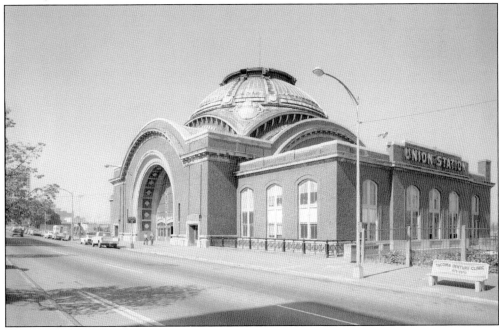

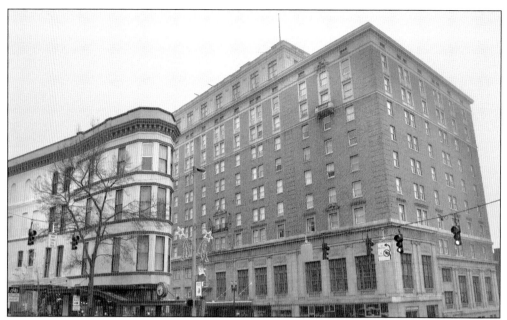

HOTEL WINTHROP. Built in 1925, this building holds a mighty history despite its short life as the Hotel Winthrop, which was named for author Theodore Winthrop through a newspaper contest. In 1938, mental patient Frank Olsen was held for over two days of questioning in Room 305 before confessing to the kidnapping and death of Charles Mattson. On April 23, 1939, an unidentified man and woman entered the hotel as guests and took their lives by using chloroform-soaked towels. They were never identified. In 1946, a young girl plummeted seven stories to her death in a fatal leap from the building. She had been attending a party in the hotel. In 1947, Harold Dahl claimed to see six UFOs off the sound near Tacoma. Men in black suits confronted Dahl and held him for questioning at the Winthrop. After this interrogation, Dahl denied his story. (Both, AC.)

HAUNTED HOTEL. With strange occurrences happening from time to time, there is no telling as to the ghosts roaming about the former Hotel Winthrop. Now that it operates as an apartment building, it seems quite odd to hear somebody knocking at the door with room service, but it happens. There is never anyone at the door, though. Could this be just a prank played by the kids in the building? Others hear running up and down the halls late into the night, but when attempting to confront the offending person, no one is ever found. Furthermore, tenants constantly complain to the office manager about capricious lights and want the wiring checked, but of course, nothing is faulty. (Both, AC.)

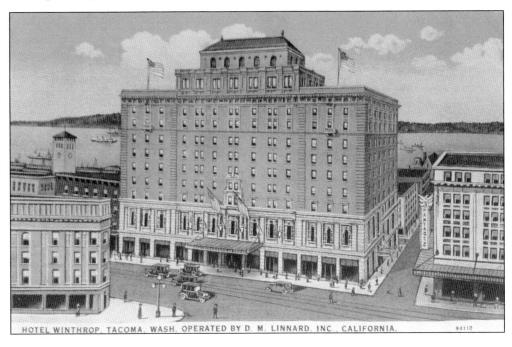

HOTEL WINTHROP, TACOMA, WASH. OPERATED BY D. M. LINNARD, INC., CALIFORNIA.

NORTHERN PACIFIC RAILWAY COMPANY.

TRANSPORTATION OF CORPSES.

TRANSIT PERMIT.

9363

☞ READ THE RULES PRINTED ON OTHER SIDE OF THIS SHEET.

In the City of *Livingston* County of *Park* State of *Montana* on the 19 day of *May* 1898 Permission is hereby given to remove the remains of *Stanley Sheard* aged *one* month *14* days, who died at *Livingston* Montana on the 23rd day of *December* 1897 The cause of death having been *Marasmus — Stomach Trouble* which is a *non-Contagious* disease, and a Transit Permit being asked for burial at *Tacoma* in the State of *Washington*

Name of Undertaker. *A Krueger & Co*

Name of Medical Attendant. *R. D. Allen*

Signed by *R. D. Allen*

Livingston

State of *Montana* date *May 19th* 1898

I hereby certify, that the body of *Infant Child of W F Sheard* named in this Transit Permit has been prepared by me for transportation in accordance with the rules of the State Board of Health, by having been *placed in a metallic air-tight case*

(Signed). *A Krueger & Co* Undertaker.

If the Disease was Infectious or Contagious, Undertaker must make following Affidavit:

State of _____
County of _____ On this _____ day of _____ A. D. 189__
before me, a _____ in and for the County and State aforesaid,
personally appeared _____ to me known, and made
oath and says that all the statements contained in the foregoing are true.
Sworn and subscribed to before me this _____ day of _____ 189__

[SEAL.]

NORTHERN PACIFIC RAILWAY CO.		NORTHERN PACIFIC RAILWAY CO.	
Station _____ 189__		Station _____ 189__	
Remains of _____		Remains of _____	
Who died at _____ State _____		Who died at _____ State _____	
Shipped to _____ State _____		Shipped to _____ State _____	
Via _____ R. R.		Via _____ R. R.	
Via _____ R. R.		Via _____ R. R.	
Taken at _____ Train No. _____		Delivered at _____ Train No. _____	
By _____ T. P. M.		By _____ T. P. M.	

Transit Permit.

No. _____ Issued to _____
Name of deceased *W. F. Sheard (Parent)*
Interment at *Tacoma, Washington*
Date of death *Dec 23rd* 189 *3* Age — years *1* months *14* days
Place of death *Livingston, Mont*
Cause of death *Marasmus, Stomach Trouble*
Certified by _____ *R. D. Allen* M. D.

WILLIAM F. SHEARD CURIO SHOP. As a noted dealer and collector of guns, William F. Sheard patented and manufactured several sites for Winchester rifles. He also ran a curio shop with oddities from all over the world, in addition to performing taxidermy. His love of the unusual was an open invitation for his friend Allen Mason to bring over his Egyptian mummy (which is detailed later in this book) for an unveiling party. The curious group unwrapped the mummy to see what was hidden underneath its dirty coverings, even though the sarcophagus was clearly marked with a warning curse about the negative side effects of any disrespectful actions against the body inside. Sheard's luck may have been cursed when he lost his son at the age of one. (Above, AC; left, WSDA.)

Four

LAKEWOOD

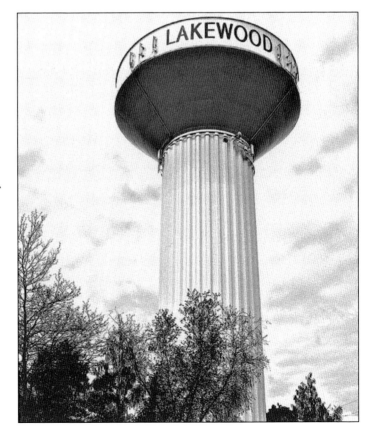

LAKEWOOD, WASHINGTON. Originally known as "the Prairie," Lakewood contained 20 square miles of land. Both the Steilacoom and Nisqually tribes used the land for food and a safe gathering spot with white trappers, hunters, and settlers. Farmers began to claim the land, and the US Army leased land as well. The name *Lakewood* was derived from the lakes and wooded areas that comprised the land. (JN.)

OLD SETTLERS CEMETERY. Donated by Frank Clark, the Old Settlers Cemetery provided free burial plots for only pioneers and their descendants. Here, burials were simple and sometimes unofficial, and therefore, the records are weak at best. The first burial at this cemetery took place in the 1860s. One notable burial is that of Albert Balch, younger brother to Lafayette Balch, founder of Steilacoom. During certain stages of the moon, Albert would become completely insane, but at other times, he was lucid. His illness was termed "moon madness," for which he spent time in an asylum. One night, when there was a full, bright moon, Albert ran through the woods behind his home with an ax in hand. His body was located the next morning with no visible cause of death. It was later determined that he had run himself to death in the light from the moon. (Both, JN.)

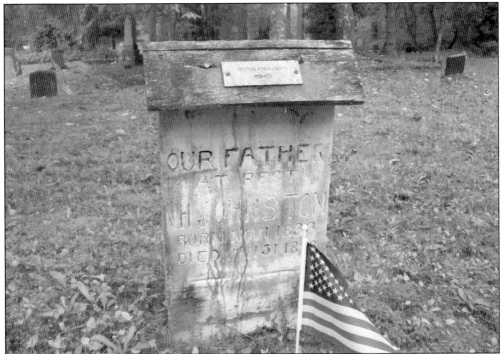

AGHOST INVESTIGATION. AGHOST Investigations has spent many nights in the Old Settlers Cemetery, roaming through its historic headstones. On these investigations, the team has captured recordings of a ghostly child asking, "Who are you?" and a woman telling the team, "He doesn't like you here!" Reports of a dark male figure lurking about come from passersby or even those who live near the cemetery. There have also been a few encounters of strange light formations floating along the cemetery grounds. (Both, JN.)

RHODESLEIGH. Rhodesleigh is often referred to as the Rhodes mansion, and it is indeed the second stately home of Henry and Birdella Rhodes. The land was originally purchased as the site for the summer home of the Rhodes family. In 1912, two small cottages were built: one for Henry and one for his son Edward. This 12,600-square-foot house was built in 1922 to honor the memory of Edward Rhodes, who had served and paid the ultimate price for freedom in World War I. The Rhodes brothers made their money by operating a department store in Tacoma. The business began small but quickly grew and expanded. The idea was that shoppers could furnish their entire home by stopping at just one store. Henry and his wife enjoyed entertaining large parties at Rhodesleigh. After a brief illness, Rhodes passed away in his home in 1954. (Both, JM.)

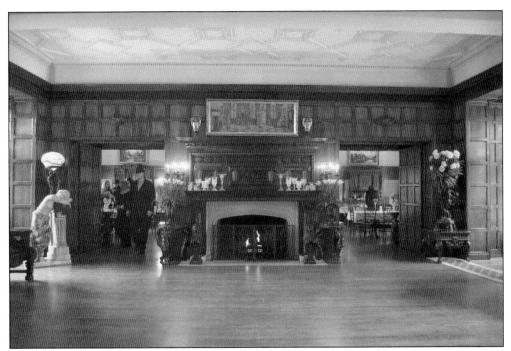

NEVER WANT TO LEAVE. It is assumed that Henry's son Edward haunts this site. For decades, many who have passed through these halls talk about the presence of the dearly departed Edward. He is mostly felt on the second floor and in the hall. They say he is nothing to fear and tends to keep to himself. Every so often, a door is heard opening or closing, and the sounds of him walking the hall just might arouse suspicion in the middle of the night. (Both, JM.)

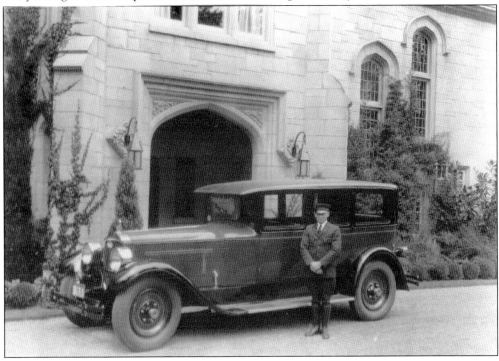

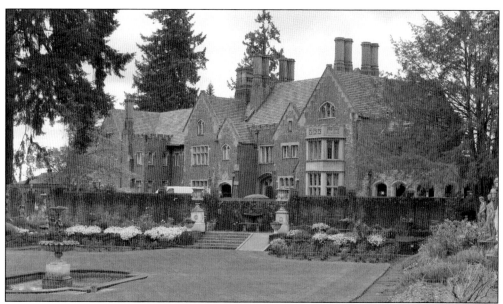

CHESTER THORNE. In 1907, Chester Thorne, a founder of the Port of Tacoma, purchased a 400-year-old Tudor manor in England as a gift for his wife. This labor of love took around three years to reconstruct, as the bricks, stained glass, and other materials were brought to Washington via ship from England. Today, several spirits are believed to reside at Thornewood Castle, refusing to leave behind its beauty. The 27,000 square feet of living space also provided the backdrop for Stephen King's *Rose Red* miniseries. The house held a starring role as a haunted Seattle mansion. King's story is pure fiction, yet it grasps at a near truth, causing viewers to wonder if it is purely imagination or based on a true story. It also adds to the haunting mysteries that surround the real home, and movie star, Thornewood Castle. (Both, LOC.)

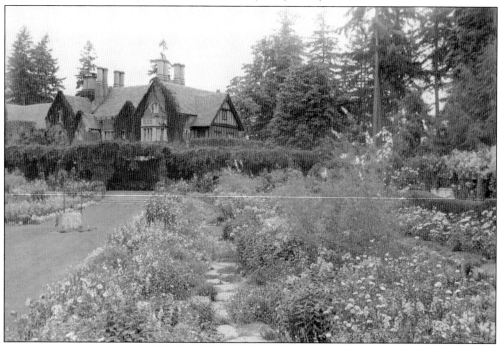

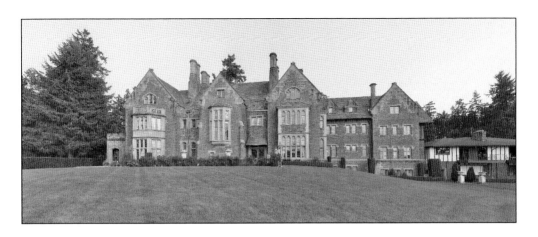

THORNEWOOD CASTLE. Today, Thornewood Castle operates as a bed-and-breakfast and often as a wedding venue. In fact, two US presidents, Theodore Roosevelt and William Howard Taft, have stayed here as well. With such a storied history, it is not surprising when guests and staff report a few oddities from time to time. Many believe the lingering ghosts are Chester and his wife, Anna, their son-in-law, and a few others who have yet to let themselves be identified. Chester is known to wander the estate, making sure everything is in order. He is often heard walking up and down the halls and stairs. Anna is known to haunt the bridal suite, her image appearing in the background when the lovely bride views herself in the mirror. She is also seen peering out her bedroom window to admire her gardens. As for the son-in-law, his ghostly figure dwells in the old gun closet where he shot and killed himself. The other spirits that roam within the walls are thought to be the souls that were attached to the original building and brought back when it was rebuilt. These ghosts are seen in period attire and are heard laughing throughout the night. (Above, LOC; below, JM.)

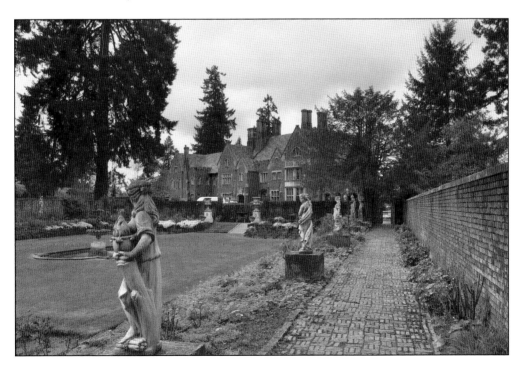

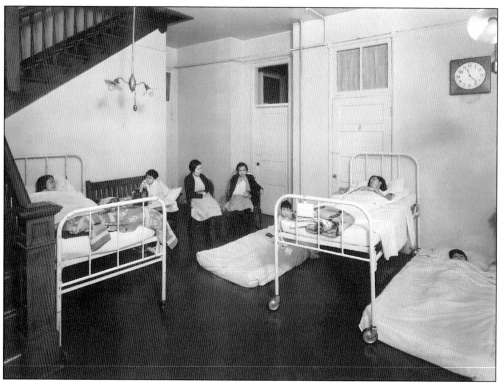

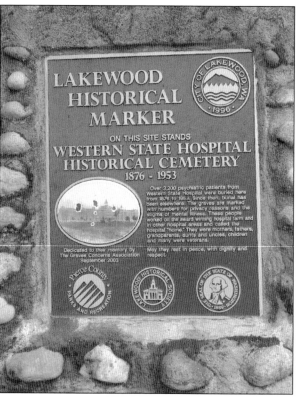

WESTERN STATE HOSPITAL. The Western State Hospital opened in 1871 and began serving patients and housing staff. By 1887, the government needed to step in due to complaints of abuse, neglect, and poor living conditions. Sadly, the number of murders and suicides at this hospital is extremely high. Actress Frances Farmer was admitted in the early 1940s with a diagnosis of paranoid schizophrenia, for which she received many controversial treatments. In fact, just before his death, Dr. Walter Freeman claimed it was Frances Farmer in his world-famous lobotomy photograph. Farmer's family strongly disclaims this rumor, yet experts agree her flat affect during interviews after her release prove the procedure was completed. Farmer's medical records can be viewed in the hospital museum, but there is no mention of a lobotomy. (Above, JN; left, LOC.)

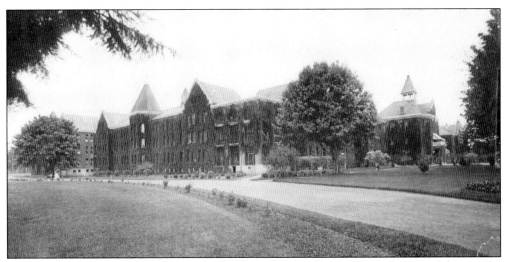

SUICIDES, MURDERS, AND LOBOTOMIES. The Western State Hospital has a long, sordid past. The hospital itself has witnessed a ghostly receptionist named Mable who now haunts the hallways. Elevator doors open and close of their own accord, often called to floors for no apparent reason. But across the street, the site of what was Hill Ward, built in 1932 as a dormitory for patients who worked in the dairy, has carried more of a malevolent haunting since it was abandoned in 1965. In the old ruins that stood here, devil worshipping is said to have taken place, and those who venture near may hear the screams of troubled souls. Individuals brave enough to enter, after dark, what is now a park have had their batteries drained and experienced manifestations pressing down on them, bringing them to a fearful panic. (Above, LOC; below, Harris Ewing.)

WESTERN STATE HOSPITAL CEMETERY. Admittance to a mental hospital was often frowned upon, and therefore, when patients died, they were quietly buried at the cemetery set aside for the hospital. Patients were never named, only identified by numbers. With over 3,800 burials in this cemetery, the Grave Concerns Organization has taken over the task of replacing each numbered marker with a proper headstone. (JN.)

INVESTIGATION AT WESTERN STATE CEMETERY. In 2002, the AGHOST team had the pleasure of investigating the Western State Cemetery. During this late-night exploration, the group encountered the shadowy figure of a man walking across the cemetery. Also captured were EVPs (electronic voice phenomena) of a woman asking for help. Several paranormal enthusiasts consider it a very real possibility that the individuals who have been laid to rest here still walk these surroundings. With a number as their only identification, perhaps the departed choose to reach out to the living just to make their true names known. (JN.)

Five

NORTH TACOMA

NORTH TACOMA. Job Carr founded much of North Tacoma and, with anticipation of the expanding railroads, built his original cabin in the North End in 1886. The North Slope encompasses over 950 properties, making it the largest historic district in the state. This district was created in response to residents of the area wanting to maintain the historic value of their homes. (LOC.)

JENNIFER BASTIAN. On August 4, 1986, Jennifer Bastian, age 13, went missing while riding her bike to the park. Although many searched for Jennifer, they would not find her alive. Joggers found her body just off of the main drag of Five Mile Drive, a long, winding loop traveling through an old-growth forest at the northern tip of Tacoma. Evidence proved murder, but there were no suspects to arrest. Her murderer has never been brought to justice, but convicted murderer Terapon Adhahn remains the prime suspect. Adhahn's name first appeared in the headlines when he abducted and murdered Amber Hagerman, the namesake for the AMBER Alert System. (Left, TNT; below, AC.)

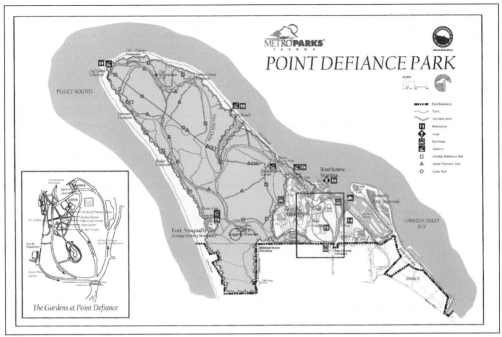

The Gardens at Point Defiance

FIVE MILE DRIVE. For the longest time, a young couple's experience here has made this a popular haunted hot spot. Rumor has it that when the couple was driving through the park after closing, they passed a young girl standing with her bicycle on a corner near the Narrows Bridge viewpoint. Concerned for her well-being, they pulled over to assist her. As the boyfriend drew closer to the little girl, he noticed she had no eyes. Terrified, he ran back to the car and screamed for his girlfriend to keep driving. As she drove away, she watched in her rearview mirror as the little girl vanished. Today, many claim to hear the sounds of this young girl's bike pedaling along the road. She has also been heard crying around dusk. (Above, Metro Parks Tacoma; below, AC.)

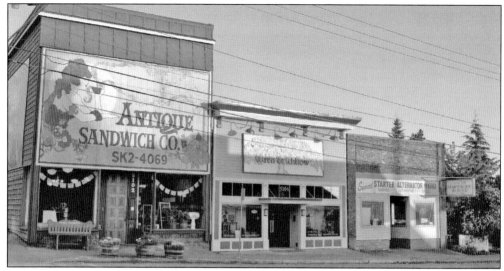

ANTIQUE SANDWICH CO. This location opened as the H.M. Anderson store in 1916, then became the A.G. Food Store No. 8, Image Youth Center, and Image Theater before the Antique Sandwich Co. opened here in 1973. It is interesting to note that this spot sold food and showed classic films long before it became a popular local restaurant featuring an open mic night and performances by local artists. (AC.)

GHOSTS OF THE PAST REMAIN. At first sight, the Antique Sandwich Co. would not appear to be a haunted establishment. In fact, the encounters are pretty rare. Perhaps it is a matter of being there at the right time. One employee just so happened to be in the right place at the right time. It was around 5:00 a.m., when he was preparing for the morning rush. As he walked by the front counter, he saw a long blonde-haired woman sitting at the counter. When he greeted her, she turned to reveal she had no eyes. Others have picked up a cold spot at the top of the stairs that sends chills down the spine. (Antique Sandwich Co.)

RHODES FAMILY. William, Albert, Henry, and Charles Rhodes opened the Rhodes Brothers Department Store in 1892. Built in 1901, the first home of Henry Rhodes is a classic Victorian located on the North End of Tacoma. While often referred to as the Rhodes mansion, it should not be confused with Rhodesleigh, the second mansion of Henry Rhodes, which is also featured in this book. (AC.)

HENRY RHODES'S FIRST MANSION. Not all ghosts aspire to scare or harm the living. In this case, a previous owner of the Rhodes mansion felt it was indeed haunted by a slim, balding, gentle man who lingered in one corner of the kitchen. Here, he would sit and watch the goings-on, fading into the shadows if anyone happened to notice him. He would also open and shut doors or turn lights on and off throughout the house. Some feel he took to the attic, where he is known to walk the creaky floors and move objects around. (BC.)

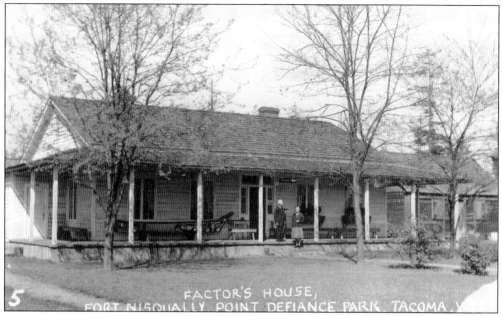

FACTOR'S HOUSE,
FORT NISQUALLY POINT DEFIANCE PARK, TACOMA, W

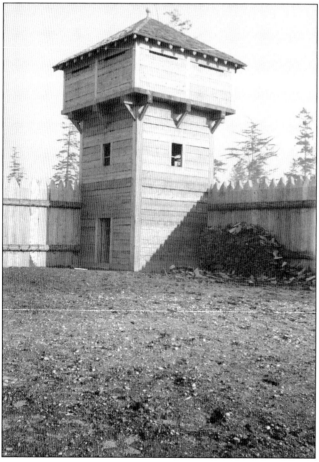

FORT NISQUALLY. When the Hudson Bay Company expanded west with its fur trading and farming posts, it found Fort Nisqually desirable as a midpoint between friendly Native American tribes. It was the first European trading post in the Pacific Northwest. Originally, the fort was located near the present-day city of DuPont. Permanent construction began around 1833, and many expansions took place over the years. Presently, the Fort Nisqually Living History Museum is located within Point Defiance. Many of the original structures were relocated to this site. In 1988, archeologists found hundreds of artifacts, which were cataloged and recorded for historical records. (Both, WSDA.)

ORIGINAL BUILDINGS HOLD HAUNTS. When it comes to history, stepping through the gates of Fort Nisqually truly takes visitors back in time. Here, the past is brought to life, along with its ghosts. The first encounter dates back to when the fort still was at rest in its original location, off DuPont Center Drive. Folks who happened to drive by would glimpse an elderly man sitting in a rocking chair on the front porch, but by the time they could pull over to investigate, he had disappeared. After relocating the fort to Point Defiance, staff and guests have seen the apparition of a man walking toward the Factor's House. Some believe it is Edward Huggins, who lived in the home with his family. There, his young daughter died in her bedroom, where the little girl's presence is often felt. (Both, SP.)

THE PAGODA. Inspired by Japanese architecture, the brick pagoda building with a green tiled roof was built in 1914 as the focal point for the Japanese gardens. It originally served as the waiting room for the streetcars that traveled through the area transporting people to the ferry from Point Defiance to Vashon Island. A saddened lover reportedly committed suicide after watching his wife sink in a shipwreck offshore. (LOC.)

THE PAGODA HAUNTING. Used today as an event venue, the pagoda seems to house the ghost of the suicide victim. In the 1920s, a newlywed couple was in the habit of riding the trolley to catch the small ferry to Vashon Island so that the wife could visit her parents. At the pagoda, they would say their good-byes until she returned later that evening. Unfortunately, on one return trip, the small boat tipped over, and due to her heavy skirts, the wife drowned. Upon witnessing the whole event from the pagoda, the husband was driven to take his own life in the men's room. Some say his hard-soled shoes can be heard walking down the east staircase or his cold presence can be felt lurking near the restroom. (LOC.)

STADIUM HIGH SCHOOL. Construction of a luxury hotel resembling a French château was brought to an abrupt halt when the town panicked over the financial losses of the railroad. The school district purchased the gutted building in 1904 with plans to open the Stadium High School. Next to the bluff where the building stands is a thickly wooded ravine known to locals as Old Woman's Gulch, of which very few know the history. Here, longshoremen's widows would leave burial markers for men lost at sea. It is also said that some of these older women built small shacks here to live out their lonely, depressing lives. Many ladies who had a husband or lover at sea would come here to watch over the waters, waiting for their ship to come into port. (JM.)

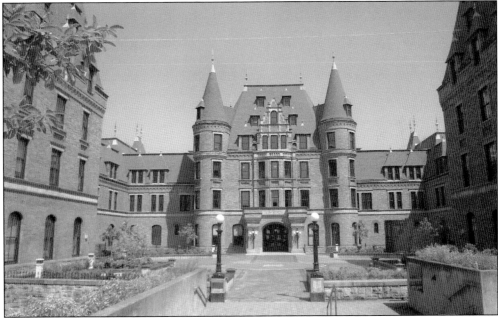

SCHOOL OF HAUNTS. Around dusk, students and faculty have seen a woman in black looking over the ravine. She is there for just a few seconds before disappearing. They believe she might have jumped to her death after learning her lover would never return. Based on the story of a student drowning in the school's pool, witnesses have seen a teenage boy standing near the pool, dripping wet and shivering. Late one night, a custodian saw this young man, believing he had broken into the school for a swim. To his surprise, the boy vanished, leaving behind only his wet footprints leading nowhere. (JM.)

GALLOPING GERTIE. The first Tacoma Narrows Bridge opened in July 1940. It was the first suspension bridge in Washington State, and during construction, workers noted its vertical sway during windy conditions, which brought forth the nickname "Galloping Gertie." Even after the bridge was open to traffic, the motion was observed, and nothing seemed to stop the sway. On November 7, 1940, the bridge collapsed due to an aeroelastic flutter of wind traveling at approximately 40 miles per hour. Though the bridge was loaded with vehicles and people, only one death occurred that day—a pet dog. Nearly 10 years later, a new bridge was built at the same location. Part of the original bridge formed the base for the new bridge, and other parts of the bridge created a natural underwater reef. (Both, LOC.)

TACOMA NARROWS BRIDGE. Have you heard the term "unfinished business" in the world of ghosts? Ghost hunters often believe that if people have time to say their good-byes during their lives, they may rest more soundly in the afterlife. Those who die suddenly or unexpectedly may not know they are dead, may want to avenge their death, or may wish to give a final message to their loved ones. Suicide victims fall into the latter category. Since the Tacoma Narrows Bridge was rebuilt in 1950, along with its twin bridge in 2007, over 25 people have plunged to their deaths. The first known suicide occurred in 1952, when William Gadbaw abandoned his car midspan and jumped. Although preventative measures have been taken, the bridge sadly remains a suicide hot spot. (Both, JM.)

ALLEN MASON. Allen C. Mason constructed a Colonial-style mansion in 1892. Mason was a determined businessman who quickly became a millionaire. In the Panic of 1893, Mason lost most of his fortune and sold his mansion to Whitworth College. Before losing his money, Mason had bought back many homes for other citizens in the town. When the mansion was demolished in 1920, the sandstone columns from the portico were relocated to the plaza, where they stand in honor of Mason. (Left, JM; below, AC.)

THE MASON MUMMY. Allen C. Mason loved to travel, and on one occasion, he brought back quite the souvenir—an Egyptian mummy. The mummified body was that of Ankh-Wennefer, who was a high priest in the Temple of Min. Mason had planned to keep Ankh-Wennefer in his mansion, but his wife refused, thus the mummy was displayed in his office downtown until donated to the Washington State Historical Museum in 1898. Mason took his mummy on outings about town, to restaurants, and even to church. (Above, AC; below, Multi-Care Imagery.)

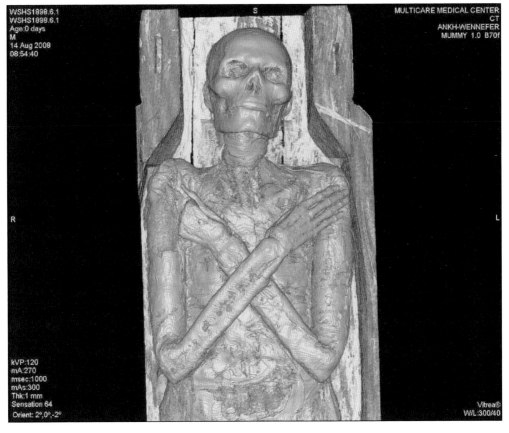

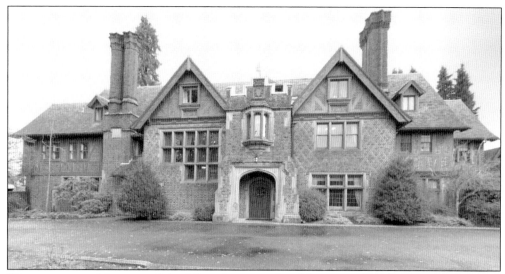

WEYERHAEUSER MANSION. John Weyerhaeuser, the eldest son of timber mogul Frederick Weyerhaeuser, often joked that his wife always got what she wanted, thus he named their home Haddaway as a pun for "had her way." In 1935, their grandson George was kidnapped, making top headlines in the news, which could explain the addition of hidden passages and extreme security measures throughout the house, including large bars to seal off the sleeping quarters at night. (AC.)

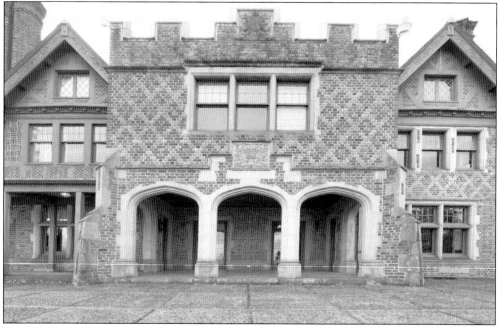

GHOST HUNTER DELIGHT. At three stories high with 50 rooms, the Weyerhaeuser mansion would be any ghost hunter's dream, like something right out of a haunted novel. The hidden passages might also hide the ghosts that only few will talk about. They say a woman is often seen walking these halls. Some believe she is Mrs. Weyerhaeuser herself. For this was her dream house, and maybe she is not ready to leave. If not seen, then one might catch a whiff of her sweet perfume lingering in the air whenever she is nearby. (www.realtor.com.)

TED BUNDY. Established in 1888, University of Puget Sound is one of the top liberal arts colleges throughout the state of Washington. From the very beginning, the college has maintained strict rules about drinking, gambling, tobacco use, and other conduct typical of college life around the country. Despite its sterling reputation, an infamous former student is convicted serial killer Ted Bundy. (AC.)

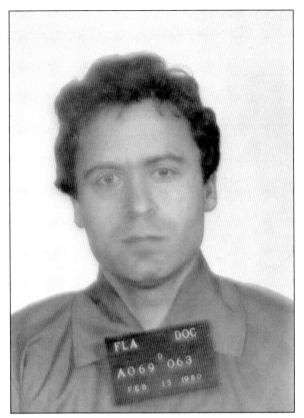

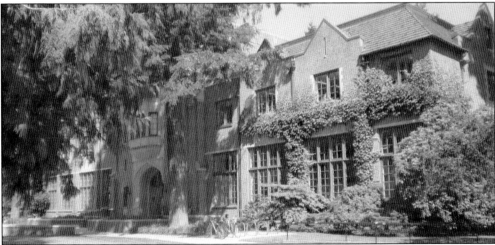

UNIVERSITY OF PUGET SOUND. The location where Ted Bundy may have disposed of his first victim is rumored to be in the foundation of one of the buildings that was under construction at the university. Students report seeing a young girl with long straight hair wandering the halls, only to vanish once seen by onlookers. She is also known to make eerie and odd sounds throughout the night. But there is another spirit that also haunts these grounds. In the Norton Clapp Theatre in Jones Hall, there is a presence that likes to mess with the sets and lights. Nevertheless, on one occasion, a student was working on the upper catwalk when she lost her balance and began to fall, only to have the feeling of someone or something jerking her back to safety. (FSA.)

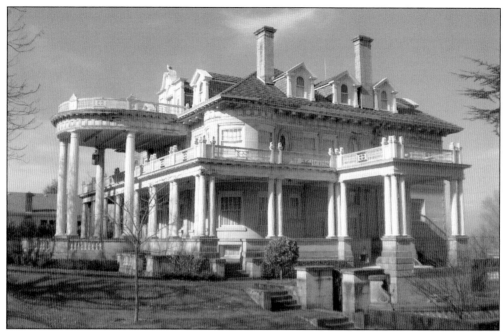

THE RUST MANSION. As president of the Tacoma Smelter and Refining Company, William Ross Rust quickly became one of the most influential men in Tacoma. In 1889, Rust established the smelter and created the one-square-mile town of Ruston for the company's employees. The smelter bound everyone and everything in Ruston, about 50 percent of which is rumored to be on ancient Native American burial grounds. Did the cursed land affect the destiny of the Rust family? As the public's concern over pollution and air quality due to the toxins released from the smelter increased, Rust moved swiftly to sell. However, he stayed on as the company's president for several years after the sale in 1905. The smelter remained open until 1985, running from the furnace first lit by Rust himself. (Both, AC.)

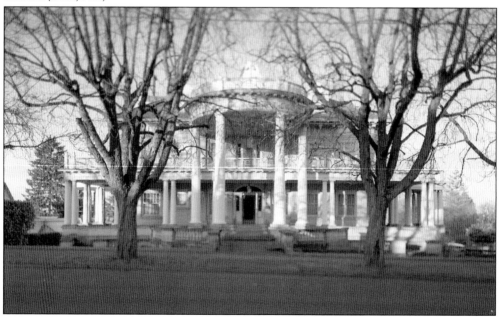

THE RUST FAMILY. Rust moved into his dream home with his wife, Helen, and their two sons, Howard and Henry. To the outside world, they were model citizens and the perfect family. In 1911, Howard died at age 24, his life taken by a ruptured artery in his heart. His family would not learn about his death until they returned from Europe a few weeks later. Helen became distraught and refused to return to the home, which was so closely associated with her son. The family lived in temporary housing until a second, less extravagant mansion was built a few blocks away. In 1928, William was hospitalized, requiring emergency surgery for intestinal blockage, but he never awoke. Helen became so sad she required placement in a care center. In 1936, her youngest son became severely ill. Henry died before the tender age of 35, leaving behind a wife and three daughters. Helen passed away just one year later. With the three most important men in her life gone, she lost her will to live and died from a broken heart. (Right, WPB; below, AC.)

HAUNTED MANSION. Utilizing the $5.5 million earned from the sale of the smelter, Rust commissioned the construction of his first mansion at 1001 North I Street. The land purchase came from the estate of the late Paul Schultz, who committed suicide in his home on Yakima Street in 1895, after embezzling money from the Pacific Northern Railroad. Already, Rust had been exposed to two cursed pieces of land. In 1905, construction began on the beautiful white mansion, which was modeled after the John A. McCall mansion in New Jersey (built in 1903, then destroyed by fire in 1927). Fortunately, the Rust mansion never burned, but the family would live in the 10,813-square-foot mansion for only about five years. (JN.)

WEALTHY MAN DIES IN MANSION. After the Rust family moved out in 1911, the home saw many owners. Orville Billings and his wife purchased the home and converted it to apartments. Billings was a candidate for governor and one of the city's wealthiest men. On April 22, 1919, Billings fell under scrutiny for possibly having illicit relations with a 14-year-old deaf and mute girl. The day before his trial, Billings sat at his dining room table showing off his new pistol to his friend and wife. A few nights prior, someone had attempted to steal his automobile. Playing with the gun in his hand, he joked about loading it with ammunition before he could stop the thief. He twirled the gun until it pointed to his head, and then with one last laugh, he pulled the trigger. It was ruled an accidental death, though many suspected suicide. (Both, SN.)

WRIGHT PARK. As the president of the Tacoma Land Company in 1886, Charles Wright donated land to the City of Tacoma with the stipulation that it be used for a public park. Wright Park covers 27 acres of land, including numerous statues and memorials, as well as an arboretum that is listed in the National Historic Register. (AC.)

MYSTERIOUS DEATHS. It is hard to believe that such a beautiful park could be the site of so many deaths. True, accidents do happen, in addition to health issues and even a few drug overdoses. However, a few murders have stained these grounds as well. In September 1910, Capt. Trovold D. Blom had his throat slashed some time late in the evening. While coroners claim it was a suicide, his friends and family wholeheartedly believe his death remains a mystery. Today, many claim to see a shadow of a man wandering in the darkness of the night. Others have heard the screams of a man echoing through the park. Could this be the captain seeking a resolution to his death? (SP.)

Six

SOUTH TACOMA

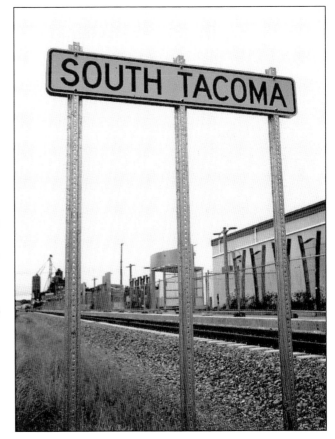

SOUTH TACOMA. Up until the mid-1800s, South Tacoma was simply prairie land called Hunt's Prairie. Formally annexed into Tacoma in 1891, the area served the railway and employed many workers. The area was then named Edison, after Thomas Edison, who was a dear friend to Henry Villard, the owner of the railroad. It was not until 1895 that the name was changed to South Tacoma. Finally, in 1974, the railroad shops closed when the Northern Pacific Railway merged with the Burlington Northern Railroad. (AC.)

PIONEER CATHOLIC CEMETERY. The Pioneer Catholic Cemetery was full, but the church had little room to expand. In 1905, it merged with the Calvary Cemetery to form one larger cemetery. Now the only Catholic cemetery in Tacoma, Calvary contains over 28,000 graves on 55 acres. One of the most notable memorials here is that of murder victim Ann Marie Burr, who disappeared from her home in 1961 at only eight years old. She was most likely an initial victim of serial killer Ted Bundy, who would have been 14 at the time. Although Bundy denied the crime until the time before his execution, many believe he killed her and tossed her diminutive body into the foundation of the Puget Sound University while under construction. Her remains have never been located. (Both, JN.)

COME AND VISIT. Cemeteries are commonly known to have ghosts drifting about late into the witching hours. Some say that a spirit might be attached to its body and is not sure how to leave. Another theory relates to the frequency with which people visited cemeteries in the 1900s, during a time when individuals were more in touch with their family, alive or dead. Survivors would spend hours caring for the graves of their lost loved ones. So maybe some of these ghostly figures are just waiting for their family to come visit. Passersby have seen a hovering light, but upon further inspection, it fades into the darkness. (Both, JN.)

A CEMETERY DIVIDED. Originally part of the Tacoma Cemetery, these neighboring burial grounds were divided into two completely separate locations due to a family battle. They are currently partitioned off with a large cement wall, but few know the story behind the divide. First known as the Prairie Cemetery, its first burials were accepted in 1874–1875. Today, the Oakwood Hills portion contains well over 6,000 graves, along with the columbarium and crematorium, which was built in 1908. The crematorium, columbarium, and funeral home are attached as one building. The columbarium has one of the few domes in Tacoma, accented with over 2,000 individual pieces of stained glass. This quiet area holds glass cases filled with urns and ashes. (Both, JN.)

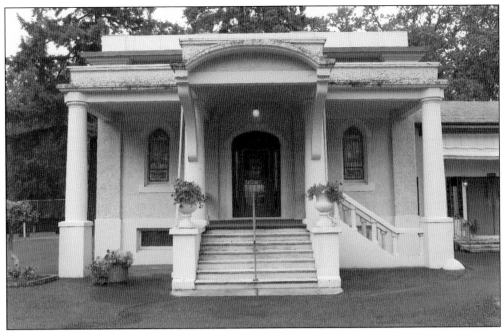

A Sanctuary for the Dead. Few know of the hidden gem that is the magnificent columbarium, which exudes both history and beauty. Still, permission is required to venture through its doors. Once inside, take a moment to peer into the glass cases, revering those who have passed before, and do not be startled by a strange sound or a voice echoing from behind. Yes, there might be something or someone enjoying the environment as well. (Both, JN.)

STEVE'S GAY 90'S. Steve Pease was born the year the Leonard Block was completed, in 1907. The second owner of the building, he was known to be a colorful, friendly man. He opened Steve's Friendly Bar Tavern in 1941, later changing the name to Steve's Gay 90's Restaurant as it expanded. This cabaret-style restaurant became an icon for South Tacoma. Its decor included treasures salvaged from many of the Victorian homes that had been demolished throughout the area. The large bar came from the Red Front Saloon. Other materials came from mansions of Henry Hewitt and Frost Snyder, as well as the Tacoma Theater and Opera House. With such a rich display of historic artifacts, residual haunts could linger. (Both, AC.)

The caption text on the image reads:

THE LOVELY CAN CAN GIRLS AT
STEVE'S GAY 90'S RESTAURANT SOUTH TACOMA, WASH.

A COLORFUL PAST. The history of this place, with its cancan dancers and live performances, is apparent. A happy, gay place it was. Today, those working or even residing in the building only wish this location still had its pleasurable environment. It seems that the many claims of murder on this property have damaged the building's reputation. Whatever is happening here seems to be malevolent, which could be the reason why the property has changed hands quite often. The situation has gotten so bad that even ghost hunters have been called in to put a stop to it all. (Both, AC.)

TACOMA CEMETERY. Established in 1875, this cemetery contains many of Tacoma's pioneers and leaders. With over 20,000 graves, Tacoma Cemetery was one of the first burial grounds in the city. A few of its most famous inhabitants include "Rockin' Robin" Roberts, Col. John Sprague, Coroner Conrad Hoska, Job Carr, Rebecca Carr Staley, Anton Huth, John and Fannie Paddock, and a handful of politicians. With so many important players from Tacoma's history, the cemetery annually hosts the Tacoma Historical Society to reenact their historical significance. The names of many of these historic figures now grace the street signs, parks, and schools of the city. (Both, JN.)

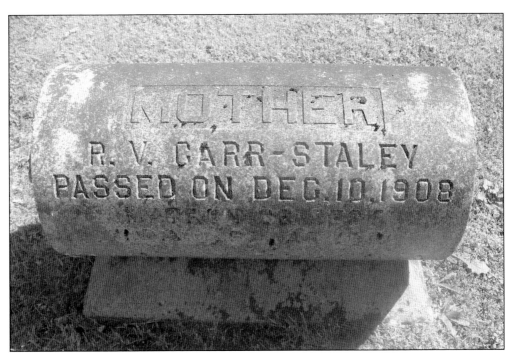

MOST HAUNTED. Folks visiting this lovely establishment enjoy walking among the historical markers and taking in the relaxing environment, punctuated by statues and angels standing guard over their proprietors' remains. This cemetery is a popular site for photographers and even ghost hunters. In fact, paranormal investigators from the show *Most Haunted* requested to visit the property late one evening. Given the proper permission, their investigation did not turn up any apparitions or disembodied voices. To their surprise, they found this cemetery a very peaceful spot where everything appears to be at rest. (Both, JN.)

PAUPER'S CEMETERY. Gone but not forgotten, this unmarked burial ground of Pauper's Cemetery is tucked behind the Oakwood Hills and Tacoma Cemetery, where it is surrounded by a fence and gate. Only a few tombstones are visible, but nearly 1,700 bodies are thought to dwell here, the records for which are sketchy at best. Many have been identified as simply "unknown man" or "skeleton" or "murdered." The earliest burial dates back to 1883. This small cemetery is also thought to have been a location for the quick disposal of contagious bodies. Diseases like small pox and tuberculosis required swift burials to prevent the spread of the disease. (Both, JN.)

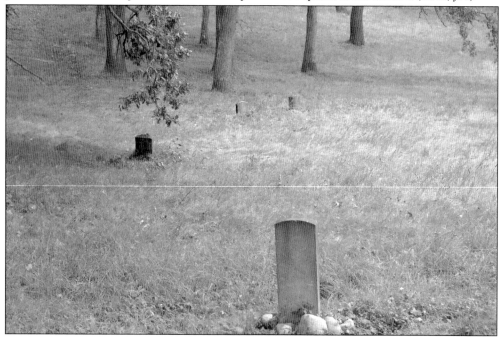

GONE AND FORGOTTEN? Now an unattended field of weeds, trees, and a random tombstone popping up here and there, the Pauper's Cemetery would seem an unlikely place for so many to have been laid to rest. Unfortunately, due to vandals, many of the grave makers that stood here have been stolen or destroyed, leaving many of the deceased unnamed and forgotten. Defacing the dead or disturbances such as these may bring forth a few hauntings. Late in the evenings, there have been reports of a young boy seen standing near the cemetery fence, but he disappears before anyone can get close enough to investigate. Others have reported hearing a woman crying around the heart of the cemetery, but the weeping stops when anyone draws near. (Both, JN.)

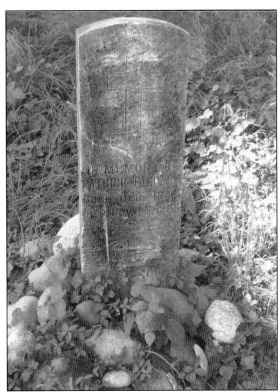

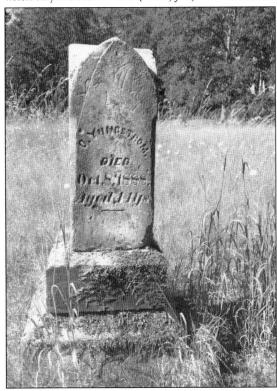

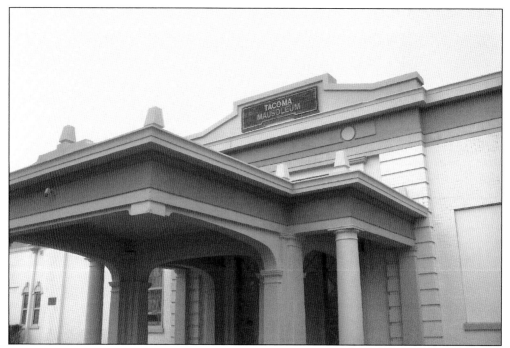

TACOMA MAUSOLEUM. The Tacoma Mausoleum is housed in two buildings and is the largest mausoleum in the area. Thousands of years ago, elaborate monuments were built to bury the dead and were believed to hold only the wealthy and elite. The first wing was constructed in 1909 and still has open spaces. Many of Tacoma's most prominent figures reside here. In fact, the W.R. Rust family "lives" right next door to the Henry Rhodes family. Currently, over 2,000 people have been put to rest here. One vault holds a 1,000-year time capsule. Sealed in 1910, it is not due to be opened until 2910. Directly next to the capsule is Orin Barlow, who was the first person to be accepted into the mausoleum. Barlow was also the first school district president and a school board member in Tacoma. (Both, JN.)

ERECTED A. D. 1910

This crypt contains historical matter and must not under any circumstance be opened until the year

2910

RESTING PLACE FOR TACOMA'S WEALTHIEST. Unfortunately, the Tacoma Mausoleum has fallen on tough times. Along with normal wear and tear, vandals have been beating on its doors, leaving visible scars. Here, pages of the city's past are stuck together, with secrets buried within its walls. To venture into the historic part, a formal request is required, and taking a recorder is suggested. Many ghostly voices have been heard echoing through its long corridors. It seems the figures of the past are willing to speak if asked the right questions. (Both, JN.)

TACOMA ORPHANAGE. Built around 1880, this Queen Anne–style mansion was the former home of Joseph Kemp. The Sisters of St. Francis purchased the home in 1938 and remodeled it to become the Tacoma Orphanage. A new three-story dormitory was also added to the estate. In 1971, both the original mansion and dormitory were demolished due to disrepair. Their fixtures and Victorian furniture were sold to raise money for the new structure. (TPL.)

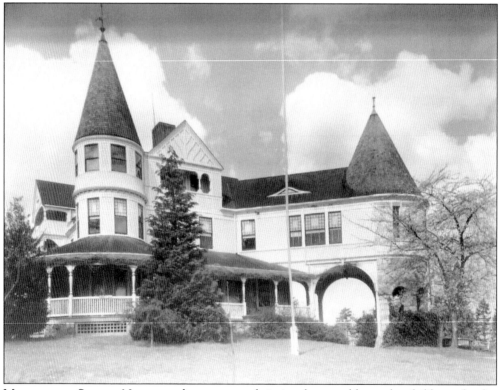

MISBEHAVING SPIRITS. Now a youth center stands in its place, and here, the children of today encounter the children of years past. Small shadowy figures are seen walking the property. The sounds of children playing can be heard at all hours of the night. On a few occasions, a crying child has been heard, only to have the weeping stop when investigated. A nun has also been spotted wandering the halls. She is believed to watch over the children at the current youth center, appearing most often when they are misbehaving. (TPL.)

Seven

STEILACOOM

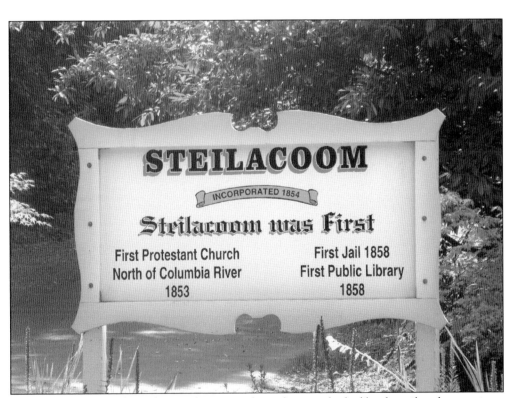

STEILACOOM. Although Steilacoom lost some glory when overlooked by the railroad expansions, the small town boasts many firsts for Pierce County and Washington State. Steilacoom held the territorial court in 1849, port in 1851, post office in 1852, county seat in 1853, public school in 1854, courthouse in 1858, jail in 1858, public library in 1858, and brewery in 1858. (AC.)

BAIR DRUG AND HARDWARE. Warren LeFevre Bair, better known as W.L. Bair, brought his pharmaceutical skills to Steilacoom in 1891, opening a one-stop drugstore where people could pick up prescriptions and purchase essential supplies. Bair also helped design much of the town, including its water system and telephone service; he even tapped into the streetcar power to provide the city with lights. The location of his second pharmacy, which opened in 1895, is now a bistro where the walls are lined with memorabilia from another time, making it a living history museum and tribute to W.L. Bair. There, a large potbellied stove served as a wintertime gathering place for men of the community to socialize. While Bair himself was a prominent citizen, his store was a fixture in the city, visited by almost everyone in town. (Both, JM.)

GATHERING PLACE FOR THE PAST AND PRESENT. AGHOST has investigated the former Bair Drug & Hardware as well. The team captured many strange events, such as an odd EMF reading and a few EVPs of a woman saying "hello" and "I'm not alone." For decades, this location has been riddled with inexplicable events. Employees and customers have witnessed flying objects and floating lights. While Bair is believed to be one of the ghosts, no one is certain as to the identity of the woman. She is heard calling the names of staff members and is seen standing near the kitchen. In fact, the cooks have constant trouble with the appliances turning on and off or increasing in temperature. (Both, JM.)

MISSING COW. J.M. Bates was a simple man who lived on the money earned from selling his cow's milk. When his cow disappeared, a saloon patron informed him that Andrew Byrd had led the cow to the slaughterhouse. Bates confronted Byrd to no avail. An angered Bates stomped off and sat in waiting for several days, stalking his prey. On January 21, 1863, while Byrd was attending to his daily routine, Bates shot him twice and attempted to shoot him a third time before bystanders intervened. Bates was arrested and taken to jail. Byrd clung to life for one more day, struggling to survive the fatal wounds inflicted by Bates. Upon Byrd's death, about 150 residents joined forces to break into the jail, wielding a battering ram, axes, and sledgehammers. While one group detained the sheriff, another pulled Bates from his cell and placed a rope around his neck. The vigilantes hung Bates from the rafters in a barn, and his body was left hanging from a pole outside the barn for the entire day. (AC.)

BYRD FAMILY. The legend of Bates's ghost roaming the streets of Steilacoom has circulated for more than a century. His ghostly form is seen with a noose around his neck and a rope trailing behind as he wanders the streets looking for his long-lost cow. His ghost has been reported around Steilacoom Lake, on the street where the old jailhouse stood, and even in the woods nearby. (AC.)

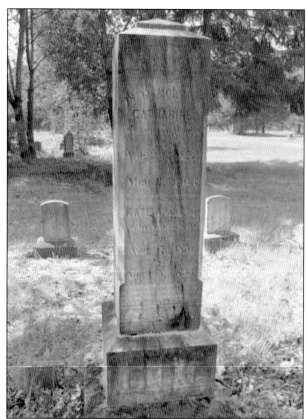

EDWIN R. ROGERS. Edwin R. Rogers was a pioneer, sailor, merchant, and justice of the peace. Built in 1891, his 17-room mansion overlooking the Puget Sound provided a home for his wife, Catherine, and their daughter, Kate. Unfortunately, Rogers lived here only one year before the Panic of 1893. With such a striking monetary loss, Rogers was forced to sell and move into his old home next door, from which he watched Hattie Bair turn his precious estate into a place for downtrodden men passing through the area. She provided this service in exchange for chores. Rogers died in his bed in 1906, still living next door to his beautiful mansion, which now stands as a landmark in the city. (Both, JM.)

ROGERS'S DEATH CERTIFICATE AND SECOND HOME. No ghost enthusiast can pass up taking a stroll by this relic, one of Steilacoom's most documented haunted locations. Now operating as office space, the E.R. Rogers mansion might be a bit more challenging to visit; however, stories of hauntings date back to 1978, when it opened as a restaurant of the same name. Many report a woman in a white Victorian dress roaming the property. On one occasion when the lights turned on in the middle of the night, a K-9 unit was called in to investigate. The dog was let loose to seek out a possible intruder, but no one was found. And despite being given the command, the dog refused to search the attic, known to be a hot spot for paranormal activity. Many of the staff refuse to go in there alone, as they have had encounters with the movement of objects, the smell of perfume, and the sight of a figure moving across the room. (Right, AC; below, WSDA.)

SEP 7 - 1906 8337

RETURN OF A DEATH.

No. of Record ☐ No. of Burial Permit ☐

Tacoma, Pierce County, Wash.

NO INCOMPLETE RETURN WILL BE ACCEPTED.

1. Name, in full *E. R. Rogers*

2. Color: 3. Sex: 4. Conjugal Conditions:

White Male ~~Single~~
~~Black (Negro or Mixed)~~ ~~Female~~ Married
~~Indian~~ Widowed
~~Chinese~~ ~~Divorced~~
~~Japanese~~

Note.—For questions 2, 3 and 4, strike out the words not applicable.

5. Date of Death { Year *1906* 6. Date of Birth { Year *1829* 7. Age { Years *76*
Month *Aug* Month *Nov* Months *9*
Day *26* Day — Days ——

8. Occupation *Merchant*
(Return occupation for all persons 18 years of age or over.)

9. Place of Birth *Maine* — State
10. Birthplace of Father *U.S.* or
11. Birthplace of Mother *" "* Country

12. Disease or Cause of Death. Duration:
Chief Cause *Valvular disease of heart*
Contributing Cause
Place where disease was contracted, if other than place of death
13. Place of Death, No. *Steilacoom Wn* Street. Ward
If death occurred in an institution, give name of same
Length of time deceased was an inmate , and previous residence

14. Late Residence
Length of residence (in city) *50 years* —
Undertaker *C. L. Hocke*
Place of Interment *Masonic Cemetery - Steilacoom* —
Signature *J. J. Amos*
(Signature Physician or Coroner)

Date of Certificate *Aug 29* 190 *6*

FERRY AND TRAIN TRACKS. The first ferry service from Steilacoom began on April 1, 1922, carrying only 16 automobiles, which would later increase to about 30. Directly in front of the ferry pier are the train tracks. The introduction of the Northern Pacific Railway came in about 1891, and Steilacoom was a popular destination for travelers who wanted to leave the city for a day or two. Approximately 500 people die as a result of being stuck by a train each year in the nation. At this location, about 12 people have died in the past 20 years, in addition to those lost at Saltar's Point, just south of the ferry dock, where there are at least six remnants of shipwrecks. (JM.)

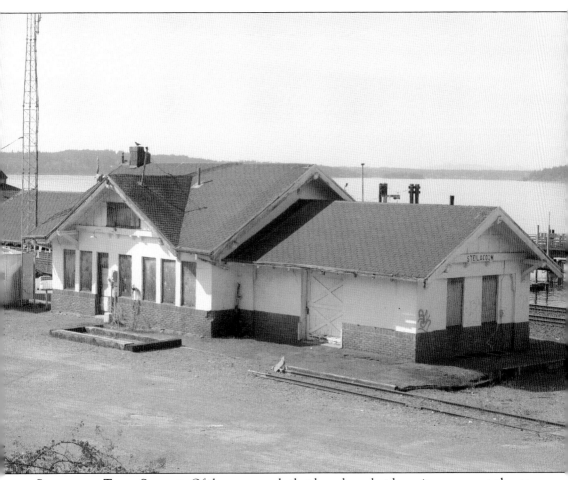

STEILACOOM TRAIN STATION. Of the many souls that have been lost here, it seems some choose to return. From time to time, witnesses have heard the phantom wail of an approaching train, the squealing of its breaks, and the screams of a dying man. An event of this sort is known as a residual haunting, the past repeating itself over and over again, maybe as a reminder of what could happen if one is not careful while crossing these tracks. (JM.)

NATHANIEL ORR HOMESTEAD.
Nathaniel Orr arrived in
Steilacoom in the summer of
1852. On his way from Virginia,
he stopped to learn about
wagon making, which added to
his carpentry skills. While in
Oregon, he learned about fruit
tree propagation. The original
wagon shop was built in 1857
and later converted into a home.
He built a second shop in which
he constructed everything from
wagons to coffins. (AC.)

THE MYSTERIOUS LIGHT. Ghost
hunters have encountered unusual
activity at the Nathaniel Orr
homestead. Stirring this curiosity
are reports of doors opening
and closing, lights turning on
in the middle of the night in
certain rooms, and strange cold
spots developing in the dining
room. It is more than just a few
nebulous instances; neighbors
and passersby have witnessed
these happenstances as well.
Could this be Orr himself? (JM.)

FIRST PIERCE COUNTY COURTHOUSE. The first Pierce County Courthouse was built in 1858 on land donated by John Chapman. The jail was also built in 1858 on land donated by Lafayette Balch, the founder of Port Steilacoom. The jail served to hold local, territorial, and even federal prisoners. The county seat moved to Tacoma in 1880, and the buildings were eventually abandoned. (LOC.)

COURT IS STILL IN SESSION. It is here that Bates's ghost still resides. Even with the building gone, it is common for these energies to attach themselves to the property. Steilacoom had its fair share of hard times, deaths, and even foul play. These tragic events can burn a scar so deep that even residual energy can still linger. So where the building once stood, a heaviness, a chill, or even a presence of the past can be felt, reaching out to touch you. (LOC.)

DISCOVER THOUSANDS OF LOCAL HISTORY BOOKS
FEATURING MILLIONS OF VINTAGE IMAGES

Arcadia Publishing, the leading local history publisher in the United States, is committed to making history accessible and meaningful through publishing books that celebrate and preserve the heritage of America's people and places.

Find more books like this at
www.arcadiapublishing.com

Search for your hometown history, your old stomping grounds, and even your favorite sports team.